Inferno

••• ✝ •••

The Trash
Project

VOL I

Inferno

Ken
Hollings

FIRST PUBLISHED BY Strange Attractor Press
in 2020, in an unlimited paperback edition.
Text © Ken Hollings 2020

DESIGN BY Tihana Šare.
TYPESET IN Tremolo & Typonine Sans.

COVER IMAGES are 'Art of the insane.
"Aquarelle decorative: Chaos de lignes et de
couleurs"', 'The creation of the Firmament
and The creation of Land. Woodcuts from
Genesis, by Paul Nash' from Wellcome
Archives.

ISBN: 978–1907222795

DISTRIBUTED BY The MIT Press, Cambridge,
Massachusetts. And London, England.

PRINTED AND BOUND IN Estonia by
Tallinna Raamatutrükikoda.

STRANGE ATTRACTOR PRESS
BM SAP, London, WC1N 3XX UK,
www.strangeattractor.co.uk

The Trash
Project

VOL I

Inferno

Ken Hollings

You believe I run after the strange because I do not know the beautiful: no, it is because you do not know the beautiful that I seek the strange.

⋯ ✛ ⋯

Georg Christoph Lichtenberg,
The Waste Books

Ladies and gentlemen...
welcome to violence

⋯ ✛ ⋯

Russ Meyer,
Faster Pussycat! Kill! Kill!

Contents

Inferno

Glossary

Index

And although these mystical
meanings are called by various
names, in general they can all
be called allegorical, inasmuch
as they are different from
the literal or historical. For
'*allegoria*' comes from '*alleon*'
in Greek, which in Latin is
alienum [strange] or *diversum*
[different].

Dante Alighieri, E*pistola* X to
Can Grande della Scala

Introduction:
Welcome to Violence

Trash has obsessed me for many years — increasingly more as a question than a desire. This obsession has always communicated itself as a violent refusal — but where do the origins of that violence lie, and where do they end? What aesthetic need does Trash fulfil? Why do we commonly find ourselves attracted to the cheap and vulgar, the discarded, the misshapen and the abject? What are we doing to ourselves when we declare that something is 'so bad it's good' — what interior order does it overturn within us? Trash represents a contradiction: a fault line running through our values and prejudices. It simultaneously attracts and repels — and in the end it betrays. When Trash opens its mouth to speak, 'welcome to violence' are the first words that come crawling out. But what else does it have to say?

Much of the material in this volume, and the two that are to follow, was conceived, researched and written during 2014 while I was being treated for cancer. Ostensibly an attempt to take my mind off the weird, mind-numbing effects of the drugs I was taking during that year, the texts I composed over this period also marked my return to an obligation I had felt for many years: to lay out some basic prin-

ciples for a Trash Aesthetics. I had been repeatedly disappointed by academic attempts to sanitise the hard, cynical poetry of Trash either by being too selective in what were determined to be 'valid' forms of Trash or by using terms and approaches that simply sucked all of the fun out of it. Applying the rules of good taste and orthodoxy to Trash led only to the middle of the road — and who wanted to go there? Meanwhile Trash remained more inaccessible to common understanding than just about any other product of civilisation. What other approaches might be possible? 'Neither high nor low — but definitely not in between...' I had written in a note to myself while attending a conference on Trash Aesthetics in Germany at a time when the tumour was already growing deep inside of me.

It became my intention to write a three-part study of Trash and Trash Aesthetics. Both subjects, it seemed to me, existed without a central premise. They might, I decided, be better explored through a triptych of extended, interconnected essays rather than by one single comprehensive argument. Trash may be defined by a clear hierarchy of values but is not sustained internally by it. Quite the contrary: on the inside Trash is very different from the forces that shape it from the outside. As the cancer started to trash my entire existence, I continued compiling notes on horror and violence, sex and fear, monsters and grotesques, alchemy and waste. Whatever was overlooked, disdained or derided as Trash became of immense value to me. These were the things to which I would return again and again during my slow return to something approaching wholeness and normality. They became, as it were, a form of distraction from myself *within* myself.

Introduction

Recovery can play strange tricks on you, however. I ended up setting aside *The Trash Project*, as I had come to call it, in order to concentrate on other things. When I returned to it, the world had shifted significantly, making my earlier approach to Trash appear naïve and highly problematic. The main nature of that shift, whether I liked it or not, can be summed up in a single name: Trump. This is a man who systematically trashes everything he touches — and, as President of the United States, his reach now encircled the entire globe. My concern was not that he soiled all that was decent but that he soiled the indecent as well: debasing Trash with his gold penthouse, his garbage lifestyle brands and his deluded sense of white male privilege. Trash as a strategy of resistance, as a refuge for creativity and a radical subversion of the ordinary had become severely compromised by the gilded excrement of his presence. 'He was post-literate — total television,' Michael Wolff wrote of President Trump. Bob Woodward went on to describe Trump in his residence 'sat in his big gold chair', responding to the fallout of the *Access Hollywood* recording. He had been caught on tape bragging about how he could grope and fondle women any time he liked. 'When you're a star, they let you do it,' he boasted. 'You can do anything. Grab them by the pussy.' Trump was the living, breathing personification of Trash. How to respond to that?

As the US and the UK continued their slide into corporate fascism, chaos was being used as a means of extending rather than exposing the rule of the social spectacle. Trash had become the carrier signal for repression rather than resistance. 'Darkness is good,' Steve Bannon informed the *Hollywood Reporter*, immediately after Trump's election

win. 'Dick Cheney. Darth Vader. Satan. That's power.' Then someone mentioned Dante's *Inferno*, and a light went on.

Trash, I came to realise, was best understood in mythological terms as a form of cultural hell — it is immediately tragic, riddled with fatal flaws and satiric play, unloosening lust and grim self-knowledge. I thought of Robert Rauschenberg's thirty-four illustrations for *The Inferno* sourced from American newspapers and magazines; and the relevance of Dante's text to today became even clearer to me — but how was I to present the deformed beasts emerging from the pit of my own 'total television' experience? My project had always been about aesthetics rather than morality: the two having become separated from each other in the frozen beauty of late nineteenth-century academic painting. Dante's *Inferno* proved to be the perfect model: an allegory of temporal and spiritual power, sin, guilt and punishment. However, unlike Dante's *Inferno*, which is a hell without hope, mine would be a hell without forgiveness, since no judgement can ever be more than provisional. Meanwhile Trash, by virtue of its boundless corruption and endless larval mutation, is the material embodiment of hope.

The more I looked at *The Divine Comedy*, the more I understood that the structuring of its one hundred cantos, taking its reader from Hell through Purgatory and into Paradise, suited my purposes exactly. The architecture of Dante's epic poem had clear implications for the three interlocking parts of *The Trash Project*. Instead of one hundred cantos, however, I would offer one hundred micro-essays stretched

Introduction

across the three parts of my project: each an individual fragment in an unstable mosaic of incidents and perceptions that lead from the subterranean world of movies in Part One to the transformative alchemies of Part Two and on finally to the disruptive sovereignties of Part Three.

In preparation for this first part of *The Trash Project*, I read nothing but Dante in different translations, including the cheap paperback edition of *The Inferno* used by Rauschenberg in the preparation of his illustrations. I came to realise that the sinners in my aesthetic Hell are not there because they deserve to be, but because it suits them — they are more comfortable in their infernal circle than anywhere else. Art is always immoral, appealing to our worst intentions. Trash declares itself complicit in this appeal. It admits both its own guilt as well as ours. Criminal and suspect, Trash is a reminder that all art is a curse.

In aesthetic terms, Trash exposes itself as a grotesque and liberating parody of sin: a wilful abdication from the demands of the ideal. We use Trash not as a way to understand order but as a means of *perceiving* that order. In this respect, *The Trash Project* is a Twenty First-Century Book of the Dead: a contemporary reckoning in the same way that Dante's *Divine Comedy* is a medieval Book of the Dead. It documents Trash not as something terminal but as an individual state of becoming — a striving towards a final condition which is only made possible by embracing the horror of disintegration. Trash is ultimately a process, which means that it is messy and unfixed.

Ken Hollings: Inferno

Meaninglessness slides about within it, confounding the orderly mind. Trash cannot be filed away as a sidebar to the history of art, progress and civilisation; nor is it predicated solely on the inversion of values or a lack of cohesion.

It is the falsity of Trash that is important — or rather, the way in which it falsifies or questions the conventions by which an accepted order of experience is given authenticity. It muddles the signs: makes a giggling mess of them and gets them gloriously wrong. The genealogy of Trash is consequently a self-critique: the awakening to itself of a dominant culture and the slow opening up of cracks and discontinuities in a hitherto seamless environment.

In aesthetic terms, Trash has always presented itself as a regressive form of the avant-garde — particularly as evidenced by movies that are, in the words of artist and filmmaker Nick Abrahams, 'more fun to read about than to see.' Certainly, Trash movies are more materially alive than any of their competently made counterparts; we are under no illusions when confronted by them. I have had enough conversations with others to understand that, when it comes to Trash, everyone has their own idea and agenda. Trash will perhaps always be a personal form of discourse or communication that exists only through its ability to evade rational and categorical thought. This constant evasion must, like transgression, constantly reposition itself — as such, Trash will betray, dissimulate and accuse; it *must* do these things or risk being transformed into something else: something 'useful', something 'good'. You cannot be pleased by what Trash

Introduction

shows you of yourself as it rolls you around in the dirt — the snickering adult idiocy, the bad faith and the cultivated illusion of desires being met, the fraudulent liberal strategies of self-determination. If we try too hard to retrieve Trash, to find only the worthy and the good in it, we quickly learn that there is nothing to be gained from understanding it. Insight is something that leaks in from another dimension — it is not necessarily present in the current ordering of a system but, rather, is hidden within its actual workings. Insight alters our relationship with that system — it marks an interior change, which is why Trash is so important to us. The study of Trash that I am offering here is one that cannot be definitive, but it *can* be personal.

Writing about Trash is messy because it will always implicate you. Trash doesn't care. It forces me to admit that I am the product of a dirty and prohibitive culture. In this respect *Inferno* follows a single twisting thread through a personal tangle of material, connecting up a series of random encounters. It deals predominantly with the history of low-budget, exploitation and underground cinema produced in America during the 1960s if only because I had felt its shadowy influence over my formative years. It infiltrated the visual language of the times, from TV shows and commercials to magazine supplements and comic books — even though, like Sid Vicious, I was too busy playing with my Action Man to pay much attention to it at the time.

The thirty-four sections of *Inferno* are an attempt to delineate the forces behind this unseen presence. I applied a 1960s timeline as

strictly as possible to the original divisions in Dante's *Inferno*, from one circle to the next. The closer my study gets to the end of the decade, the nearer to the frozen core of Hell readers will find themselves. I decided to accept whatever this device would throw up in the way of correspondences, conflicts and shifts in significance. The decade that emerges is one that gave itself over to the furtive celebration of both privilege and deprivation — and therefore judged itself innocent of either.

What I had identified in *The Bright Labyrinth* as the 'Electronic Delirium' of the 1960s had a distracted and distracting content, which is referred to here as the 'Purple Death'. That this title should have leaked through from the low-budget movie serials of the late 1930s and early 1940s should come as no surprise. Their mouldering exoticism and clunky futuristic modernity had a lasting impression upon the types of cinema I describe in *Inferno*. Garish and enflamed, the Purple Death is a technological infection that spread itself thickly across the entire decade. In their representation of nervous libidinal drives, the underground film and the dirty movie are closely aligned. Each is involved with playing out the cinematic medium as an expression of sex and death. Each is an embodiment not of love but of a certain fascination with its absence: with lust and carnality mythically portrayed — both with and without irony at the same time.

Jack Smith was right when he saw in Trash the materiality of creation. You will get a more intimate sense of a society by studying what it *throws away* rather than the values it claims to preserve. The junk-

Introduction

yard is haunted by the search for parts — one defining characteristic of a technological culture is the careless way in which it squanders what it has just produced. In the trickle-down economy of waste, those who scavenge own the means of reinvention. From their radically different positions, Jack Smith and Andy Warhol, Kenneth Anger and Russ Meyer, Von Dutch and Ed Roth all participated in the same subcultural practice. Like it or not, they shared a similar, sharply defined sense of self-determination. Do we still dare to follow their example — particularly in a century that none of them would ever see? If Trash isn't taking you into strange and dangerous territories, what is the point of it? It should lead us far from home and abandon us there. As Dante discovers at the very start of *The Divine Comedy*: getting lost is the first significant step towards salvation.

Creativity must renew itself, even as our current culture uses everything up. The future is already the Trash of the present. To post something online today is to throw it away. As it was always destined to do, the Internet has become a vast, ever-expanding Trash pile. This should not, however, blind us to the ugliness, meanness and stupidity of our current location. Trump in the White House is an argument we can never win: the presidency as horror movie sex comedy, populated by porn stars, victims, lawyers and abusers. The cruel and careless despoiling of the human pushes culture further back into cynicism, resentment and despair, which are among the bitterest forms of oppression. The result is not barbarism but puritanism. Those who rebel are seen as filthy and hostile to the good order of things — such people should be ashamed of themselves.

Ken Hollings: Inferno

Puritans foment civil wars, not revolutions. Shame becomes a secret vice for them. Except that Trash can never be reformed or rehabilitated. While writing the final version of *Inferno* I often found myself defending the indefensible. I ended up taking Trash seriously enough to protect it because, in its leering, misshapen and compromising way, it is actually *worth* protecting. Trash can never save us — it can only infect us; but in this infection lies a chance for change.

It was Matthew Frame, responsible for the amazing panoramic illustrations in *The Bright Labyrinth*, who first spoke to me about Dante's *Inferno*. That was in the dark weeks following Trump's inauguration. Matt's help in making the connection between *The Trash Project* and *The Divine Comedy* was invaluable, and I would like to acknowledge my indebtedness to him here. I am also grateful to Jörg Scheller for inviting me to speak at the High Trash conference in Siegen in the early summer of 2013 — the starting point for a lot of the material in this current book. People too numerous to mention have played a key part in the development of my *Inferno*; each of them enthusiastically joined me outside the gates of Athens to rehearse the subject of this book. I would, however, like to single out the following for their advice and encouragement: Edwin Pouncey, Roger K Burton and everyone at the Horse Hospital, Nick Abrahams, Will Fowler, Vicki Bennett and Cathy Ward.

I am, as always, grateful for the support and assistance of Strange Attractor Press, most notably Mark Pilkington and Jamie Sutcliffe, for helping me to raise Hell on Earth. Special thanks are also due

Introduction

to Tihana Šare, not only for her deft layouts and designs for my *Inferno* but also for the distinctive chapter headings — created from an 1825 edition of Dante's *Divine Comedy* illustrated with engravings by Bartolomeo Pinelli, which were found in the outer circles of the Wellcome archives and those at Cornell University Library.

If any of the shades described here should offend, remember that they're even worse in real life. There is a scene in Shakespeare's *Midsummer Night's Dream* where Theseus and his Athenian court take turns to mock a homespun interlude written and performed by local labourers, as if this were some episode of *Mystery Science Theatre 1600* intended for a Renaissance audience. Except that the performers' crude theatrics have a satirical force that rises above the courtiers' elevated snark. After a fanfare of trumpets Peter Quince's Prologue to their most 'lamentable comedy' says it all: 'If we offend, it is with our good will. That you should think, we come not to offend, But with good will.' Like Peter Quince and the rest of his company, the following pages are nothing more than clumsy shadows projected onto a wall to pass the hours before midnight. 'We are not here...' says Quince — and we aren't going anywhere either.

Ken Hollings

London
Easter 2017 – Winter 2020

Inferno

A Genealogy of 1960s Trash Culture

Life flitted across the screen before their smarting eyes: life chopped into small sections, fleeting, accelerated; a restless jerky fluctuation of appearing and disappearing, performed to a thin accompaniment of music, which set its actual *tempo* to the phantasmagoria of the past, and with the narrowest of means at its command, yet managed to evoke a whole gamut of pomp and solemnity, passion, abandon and gurgling sensuality. It was a

thrilling drama of love and death
they saw silently reeled off; the
scenes, laid at the court of an
oriental despot, galloped past, full
of gorgeousness and naked bodies,
thirst of power and raving religious
self-abnegation; full of cruelty,
appetite, and deathly lust, and
slowing down to give a full view of
the muscular development of the
executioner's arms.

··· ✝ ···

Thomas Mann, *The Magic Mountain*

The incredible obscene, thinly disguised references and situations that slip by in Grade B movies, the double entendres, perversion, sadism of popular songs, poltergeist knockings and mutterings of America's putrefying unconscious, boils that swell until they burst with a fart noise as if the body had put out an auxiliary ass hole with a stupid belligerent Bronx cheer. Did I ever tell you about the man who taught his ass hole to talk?

··· ✝ ···

William S Burroughs, letter to Allen Ginsberg, April 26, 1954

The
Dark Wood

In which terrifying creatures bar the way

··· ✚ ···

Woke up lost in the Twenty-First Century wondering how I got here, surrounded by such ugly Trash — where did it all come from? Thought once again of the President of the United States on the 2016 campaign trail posing on his private jet with a $20 bucket of KFC complete with biscuits, large slaw, two large mashed potatoes and gravy. It was all over social media. But who eats KFC with a polished steel knife and fork? With salt cellar and peppershaker arranged negligently around an unopened copy of *The Wall Street Journal*? Who participates so willingly in such a staged endorsement of values? And what precisely are those values? *'Chicken, chicken, chicken,'* runs a KFC mission statement. *'See? We are still called Kentucky Fried Chicken; we started using KFC 'cause it was fewer syllables.'* Meanwhile the President of the United States has become executive producer of the worst reality TV show in human history: Earth in the Twenty-First Century.

The future is the Trash of a dangerous present — the remnants of a used-up life. My childhood became strange to me the moment I discovered that the framed art print that had dominated the living room where I grew up depicted a cockfight — a staged blood sport in which birds claw each other to death within a darkened enclosed ring. Vladimir Tretchikoff's *Fighting Cocks* was a mad flurry of feathers and talons — a violent spiral of red and yellow paint splashes spinning out into a churning darkness barely contained by the modest cleanliness of its white frame.

One cockerel bears down upon the other, preparing to trample him beneath his feet — the other is in the process of moving his head, but this illusion of rapid movement suggests nothing more dynamic than submission. The extreme edges of the scrabbling vortex containing the two male birds flares from the orange at its heart to a deep crimson slashed with cobalt blue towards its edges. It achieves this effect not by blending these shades together but by letting them dazzle — ripping the eye. One of the white cock's feathers has detached itself and is floating gently back to earth on the opposite side of the canvas — his tail in the process of being broken or torn apart. It takes a

1
The Dark Wood

while to notice that the green cockerel has also lost a tail feather — caught in a stray current from the fight and rising on the opposite side of the canvas. The separation of the birds and the opposition of their flying feathers suggest some kind of alchemic arrangement. Even now it is not hard to see which of these two birds is going to triumph and which is going to die.

And I grew up with that — Tretchikoff's *Fighting Cocks* hung over the open-plan hearth not too far from the TV where I watched *Batman*, *Bewitched* and *The Man from U.N.C.L.E.*, first saw *This Island Earth*, Douglas Sirk's *Imitation of Life*, and Tony Hancock in *The Rebel* — and later still dreamed of seeing movies like *Teenage Frankenstein* and *Invasion of the Hell Creatures*, which existed for me only as black-and-white production stills in magazines and film rental catalogues.

Children with access to television grow up to an endless succession of fatalities — the two cocks clawing each other to death above the family hearth merely confirmed this. An older child might have imagined the scene wreathed in tobacco smoke and the smell

of sweat and alcohol — a sacrificial rite for a secret masculine order that existed somewhere outside my childhood world of Jonny Quest and the X-Men. It hung like a curse behind the bright promise of the 1960s. Compare this scene with the sarcastic ruminations of Richard Hamilton's *Just what is it that makes today's homes so different, so appealing?* created for the 1956 exhibition 'This is Tomorrow'. Hamilton answered his own question by placing a body builder and a burlesque star in the living room: us consumer goods capable of moving and posing. Instead of fighting cocks on the wall he offers an unidentified Victorian portrait and a *Young Romance* comic-book panel. Vladimir Tretchikoff's stunted sensibilities produced the green-faced Chinese Girl, the dripping glacial eroticism of the Birth of Venus and prima ballerina Alicia Markova as a dying swan, her gesture of collapse closely shadowed by an actual dying swan. Somehow the Pop artists of the early 1960s didn't quite get around to including such creatures among their source material. They were still walking in Ruskin's Venice, not Benjamin's arcades. And yet reproductions of Tretchikoff paintings existed in their thousands at the time — alongside comic-book covers, 45 rpm singles, newspaper headlines, advertising hoardings, commercial jingles and glossy pinups.

I
The Dark Wood

Trash has always served my dreams well — that is to say, Trash has been the outer form, the material expression of my dreams: of tomorrow, of life in space, of the blissful alienation from this world that I have always craved. I had no idea how strange my childhood world had made me until I emerged from under its spell — it is a strangeness that only greater clarity can bring. Trash has existed for me as pictures, sounds, gestures, plastic toys and movies. It reeks of sin — but the wrong kind of sin: conjured up not to bring knowledge or some terrible liberation but to be forbidden, easily dismissed and tightly regulated. The time has come to expose the complex connections between that living-room experience and the culture of which I am a product. It must also be an attempt to understand the pathology of a specific act of refusal and its results today — one glance at the President's bucket of chicken is enough for me to see that this is not about nostalgia for the past or for the haunted sunshine of 1960s pop culture. It is a confession and a self-autopsy — perhaps even an admission, not of guilt or complicity, but of a certain lack of awareness that only revolt can trigger. Confession is a continuation of the crime in a different form — our horror at the President's gilded luxury lifestyle suggests as much.

I grew up under the shadow of the Twenty-First Century. I thought movies, TV and comic books were real life because they filled my life. I thought I was going to inherit the future. The worst and meanest trick that the current regime can play upon the people is to make them deny or doubt the reality and importance of their own culture. 'As everybody knows, I drink Diet Coke and nothing else, night and day,' Karl Lagerfeld publicly asserted before going on to design a series of limited-edition Diet Coke bottles. According to one breathless account, he had his own Diet Coke butler and is rumoured to have drunk it from a crystal glass. On average the President consumes twelve cans of Diet Coke a day.

It is our duty to create our own Hell — this is how we damn ourselves. The future is just a branding exercise that got out of hand.

The Descent

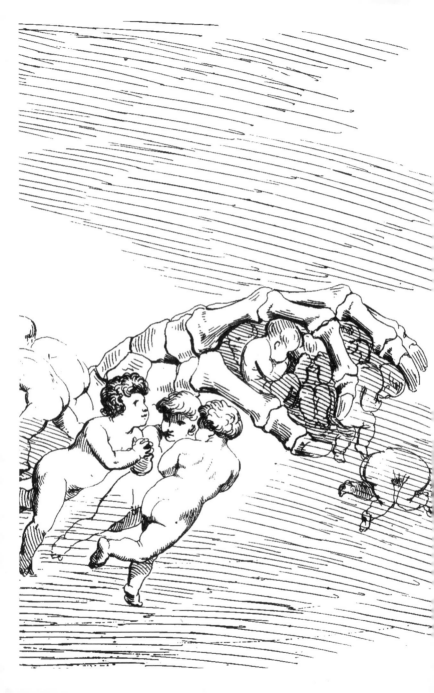

The future begins and ends with an uncertain premise

··· ✝ ···

And now I seem to be present at the dress rehearsal for some disastrous reoccurrence. 'C'mere.' White House Press Secretary Jerry Ross leans provocatively against a marble bust of John F Kennedy in Tim Burton's *Mars Attacks!*. He purses his lips, smiles then flips JFK's head back to reveal a red button. This brief gesture echoes one made by Adam West on TV during the 1960s — except that back then it was a bronze bust of Shakespeare on a table in the library at stately Wayne Manner. Jerry presses the button, and a panel in the alcove behind him slides back. 'We call this the Kennedy Room,' he announces to the gum-chewing blonde seductress who glides silently past him into the swinging bachelor lounge that lies beyond, gleaming darkly like something left over from the Playboy Mansion's glory days: complete with circular couches, martini glasses, mood lighting and exotic fish. This is a scene from an alien invasion that has been going on for years.

In the depths of the Millennial Fold between the Twentieth and the Twenty-First Centuries, Trash offered the surprise of the familiar, distorted and re-fracted through the mass-produced image. Released in 1996 and based on a set of 1960s bubble gum cards, *Mars Attacks!* resurrects the star-studded disaster movies of the past. Tom Jones and Joe Don Baker, Pam Grier and Jim Brown, Rod Steiger and Jack Nicholson are all shown busily trashing themselves in a merry postmodern apocalypse. Plastic Vegas tat and trailer parks, oil on velvet paintings and black light posters, snow globes and videogame arcades play their part in the casual devastation of the Earth carried out by creatures from another world. Even the Twin Towers appear in a brief establishing shot.

Trash expresses a wearied acceptance of surfaces and facades. It is the sign of something being eaten away inside. This inner life is only partially hidden, while the logic of its decay provokes a bitter form of laughter — the laughter of recognition, not of the familiar but of something distorted within us. As such, Trash represents a failed ecstasy — a derangement not of the senses but of values. Alien invasion, environmental crisis and cultural erosion become key themes. Big-ticket directors

II
The Descent

offer gigantic cartoon images of our universe on the edge of collapse, offering expensive violence on an inhuman scale. Inspired by sci-fi author Robert Heinlein's fictional treatise on force as the supreme authority, Paul Verhoeven's *Starship Troopers* is a 1997 wartime propaganda reel aimed directly at fascist youth in Twenty First-Century America. It features teenage soap stars getting bloodily dismembered by giant insects from outer space. 'We're in this war for the species, boys and girls,' military scientist Carl Jenkins reminds them, dressed in a formfitting black leather uniform. Children stomp cockroaches into paste while their teacher looks on, laughing insanely. In Homeric battles ranged across blasted plains, the giant bugs tear off limbs and melt human flesh, flinging blood and guts everywhere.

Sometimes they even suck out the brains of their victims. 'Frankly I find the idea of a bug that thinks offensive,' declares a TV commentator on the possibility of distributed insect intelligence. Exploitation movies, outsider art, fake exotica, lounge music and Bettie Page photo strips take on a spreading viral presence within the Millennial Fold. Retro culture becomes the new hive mind — a mutated form of pulp modernism starts to evolve. Alien creatures rise from the undersea depths

between shifting tectonic plates. Released in 2013, Guillermo del Toro's *Pacific Rim* depicts giant robots and *kaiju* relentlessly trashing this world in preparation for the next. 'Every single *kaiju*...its mind's connected,' Dr Newton Geiszler stammers incoherently about his latest discovery, 'the species has like, a hive mind.' The monsters are gigantic clones manufactured by aliens operating deep below the ocean floor. 'An advanced civilisation is by definition not barbaric,' Professor Donald Kessler reassures the President in *Mars Attacks!* In the tangled inconsequence of their plots all three of these films contain the disconnected fragments of a mythology that has yet to come into being: Trash culture as the spreading first wave that prepares the way for complete alien takeover. 'But don't you realise you're destroying the Earth?' a recovering alcoholic wails in a Vegas hotel bar 'All this greed, this money system...you're destroying everything.' There is a pretty high body count in *Mars Attacks!*, *Starship Troopers* and *Pacific Rim* — each of these movies is a city built on the downward slope of the same volcano, creating a world that will eventually embrace the alien. 'We practically terraformed it for them,' comments Geiszler, using the wrong term to make the right point, 'cause now they're coming back and it's perfect.' The Earth has already terraformed itself, and we're the ones trashing it. 'Maybe we should be destroyed,' the alcoholic concludes. 'The

II
The Descent

human race doesn't deserve to live.' So where do we go from here? 'Trash Utopia' is such a contradiction in terms.

Bad movies for bad people: how else can we define Trash except as an act of refusal? The more refined sensibility bears a double imprint of its culture, the second one subtly etched in disappointment, sarcasm and contempt. Misjudged performances, flat lighting, perfunctory sets and stock footage open up blank spaces for caustic fantasies and asides to swarm in. These are the troubled dreams of a bad conscience — mass-produced desires sold on the sly to adults only. Who could resist a quick peek through the heavy black curtain with its smell of smoke and dust and other bodies? American cinema in the 1960s defined reality itself — not just the politics and culture of the times. Movies like *Love is a Four Letter Word* by Bob Cresse and R L Frost exist today as a bleak monochrome projection into an empty future. A young male voyeur stares at women undressing through venetian blinds. His obsession becomes a form of science fiction: endless striptease routines juxtaposed with ads on the radio, news of a New York plane crash that kills eight, tranquilisers, frozen vegetables and that evening's meatloaf. Bondage and fetish scenes, soft-core loops and live sex shows

are all registered with the same blank structural gaze as the alien devastation of a familiar world continues.

In a lonely voiceover the voyeur describes reality as 'a million blackbirds gone mad in a red neon sky'. My earliest memory of Hell is my first visit to London as a small child. Overwhelmed by the endless crowds and passages deep within Leicester Square underground station, I became transfixed by a vending machine on one of the platforms. I reached up to push a coin into the slot and pulled out a pack of HOLLYWOOD chewing gum — I still remember its bold red, green and white design. With a sudden dark roar a train emerged from its tunnel, causing me to drop my pack of gum. It got wedged inside a crack in the platform, but I managed to work it out again with one of my fingers, nearly missing the train, in a panic, the doors slamming shut behind me, a child lost for a moment in the Underground.

And my memory reaches back to the fantasies of a future that existed before I was born — when art was an outbreak of mass insanity.

The Antechamber

Where the inscription over Hell's entrance can be read

'FOLLOWING IN THE WAKE OF THE DISTRESSED CONDITION OF THE WORLD, WITH DICTATORS, WAR AND RUMOURS OF WAR,' a voice grimly announces, 'A RAVAGING PLAGUE HAS VISITED THE EARTH: THE "PURPLE DEATH" THAT LEAVES ONLY A PURPLE SPOT ON THE FOREHEAD OF ITS VICTIMS...' We open on scenes of international panic — in their public confusion the masses take to the streets and occupy city squares. The whole world has been plunged into chaos. Crowds and speeding ambulances fill the screen. 'PURPLE DEATH TOLL MOUNTING HOURLY,' runs a newspaper headline, 'SCIENTISTS BAFFLED AS TO CAUSE.'

So begins episode one of *Flash Gordon Conquers the Universe*, a Universal Pictures movie serial first released in 1940. The Purple Death is seen to claim only one anonymous victim, struck down on the sidewalk

at the start of the episode. A doctor is on hand to point out the symptoms to a group of alarmed bystanders. A mounting sense of turmoil and urgency is created through an extended montage of clips taken from old newsreels accompanied by a barely coherent soundtrack of shouting voices, wailing sirens and dire pronouncements. Sometimes culture is just good crowd control.

Four years later the Purple Death strikes again at the start of a 1944 movie serial from Republic featuring Captain America. Once again its effects are immediate and chaotic. A mysterious voice identifying itself as 'the Purple Death' urges men to kill themselves in a series of violent, self-destructive ways. The first victim is ordered to drive his car off the road: stock footage shows an automobile plunging over a cliff. A screaming newspaper headline confirms the mysterious death: 'J V Wilson Victim of Purple Death'. A second man is shown reading the same headline in his skyscraper apartment before being commanded by the Purple Death to throw himself out of a window. 'The death of Harold Jackson, well-known attorney, is another link in the chain of mysterious crimes known as the "Purple Death Murders,"' a news broadcaster informs the lis-

III
The Antechamber

tening public after a third victim shoots himself in the head. 'In each case a subtle unknown poison has been found in the blood of the dead men.' The Purple Death is a technologically transmitted epidemic: reproduced from old movie clips, radio announcements and newspaper headlines. A mass contagion for an age of mass communications, it reproduces itself by infecting everyone within the reach of the world's media. Meanwhile the Purple Death's fourth victim, Professor Lyman, steps off a curb in front of a speeding truck.

Associated with the artificial and the exotic, purple not only appears with the least frequency in nature but is also the colour of the first mass-produced dye: 'Mauveine' discovered by William Henry Perkins in 1856. Forcing out the duller plant-based dyes of the period and staining the canals and waterways around the factories that use it, Maueveine purple becomes one of the most highly visible industrial pollutants.

The Purple Death operates solely as an illusion, a contagious dream made up of pre-recorded words and sounds cut together with images that have been

around so long that they have merged into collective memory. A carefully edited assemblage of pre-existing details, it is a communication that cancels itself out by simply informing us of what we already know. The Purple Death threatens entire populations and yet quickly fades from the narrative: a lost movie that disappears inside another movie. The Purple Death exists as a form of visual pollution that blends in with the immediate environment, transforming it completely. Who, after all, dies of the 'Purple Death' in a black-and-white movie? Neither *Flash Gordon Conquers the Universe* nor *Captain America* exists in anything but the cheapest monochrome, except for the gaudy intensity of their scripts. The Purple Death, in other words, reveals more than its victims are initially prepared to accept. Made to capture the attention of the immature, the unsophisticated and the undemanding, the movie serial emerges as an assemblage of the outmoded, the overlooked and the undervalued — and as such can only be seen as the pathogen for a far deeper and more pervasive disease.

'Science-Fiction rendering of the Minotaur myth,' underground moviemaker Kenneth Anger writes of his short film *Prisoner of Mars*, completed in 1942 but later withdrawn. 'A "chosen" adolescent of the future

III
The Antechamber

is rocketed to Mars where he awakens in a labyrinth littered with the bones of his predecessors. Formal use of "serial chapter" aesthetic: begins and ends in a predicament.' Further examples of Anger's sly transformation of Flash Gordon movie serials into a dark, death-obsessed focus on sexual power will not be difficult to discover.

Flash Gordon's adventures in outer space take place amid a bafflingly eclectic mix of historical periods and styles: helmets and breastplates worn by Roman centurions appear alongside medieval staircases, ancient Egyptian statuary and palaces from the pages of *A Thousand and One Nights*; spaceships and submarines coexist with dungeons and swords. The cosmos is revealed to be a cut-up of different periods, styles and technologies. The otherworldly appears to occupy no specific time or place. Its constituent parts fail to sustain a relationship with the whole except as exotic fantasy. An unstable ambiguity that cannot easily be resolved, it is the sublime viewed purely in terms of the contradictions it arouses within us. At the controls of his rocket ship and far above the Earth, Flash quickly traces the source of the Purple Death back to the planet Mongo and its absolute ruler, Ming the Merciless.

That a deadly plague threatening the public should be purple, a colour associated with imperial power since the days of Roman rule, comes as no surprise — nor that the man behind the contagion is the Emperor Ming. Like the plague he inflicts upon the people of Earth, the Emperor Ming is another composite of familiar mass-produced details. From the drooping moustache and shaved head to his high-collared robes with flowing sleeves, Ming's cruel exoticism is a familiar grab bag of second-hand finery, cheap painted scenery and even cheaper sideshow attractions. Ming's palatial court is constructed from old movie props, his palace a collection of cardboard towers. In all his tawdry splendour Ming the Merciless is the orientalist counterpart to Flash: both represent the uncertainty and shock of a mass culture struggling to come to terms with its own progressive industrialisation.

A modern mythology of collapsing expectations emerges from this early science fantasy — and the 1960s will soon be caught in its monochrome blast.

First Circle

Behold the limbo of
the invisible dead

Flash quickly discovers that the Purple Death is being dropped into the Earth's atmosphere as 'electrified dust' from Ming's rocket ships. 'The power is derived from a strong beam of light reflected from pure Thelenium, a new element, which gives the light great properties and permits it to be transformed into other forms of energy,' Dr Zarkov, Flash's constant companion, explains. 'And it is this Thelenium that energises the Purple Death Dust.' Zarkov knows a lot about science — but, like all good scientists, he lacks the necessary imagination to be truly evil.

••• ✝ •••

In *Captain America* the Purple Death's fourth victim, Professor Lyman, makes a startling discovery just moments before his death. 'How did you find out about my vibrator?' the old square gasps when confronted

by criminal genius Dr Maldor, intent upon interrogating the drugged scientist about his latest invention: the 'Thermo-Dynamic Vibration Engine'. Under the influence of the Purple Death, Professor Lyman spills everything: 'It is a device for harnessing light and sound waves into a powerful force which will disintegrate any known material.' Dr Maldor instantly understands how easily such a device can become a weapon of destruction.

Ming the Merciless and Dr Maldor think along similar lines: light and sound have unlimited destructive power. Cinema becomes a mechanical device able to obliterate the entire world at precisely the same moment in world history that motion pictures are asserting themselves as a technological means for mass domination and control. The 'electrified dust' through which the Purple Death contagion is spread can be seen hanging in the illuminated shadows of the movie projector's beam — something that only Ming and Maldor have the vision to appreciate fully. Light beams and mysterious rays create Trash fantasies out of the naked power of the moving image. Ming has armed himself with a 'destructo ray', a 'great fire pro-

jector' and a plain old-fashioned death ray. Meanwhile Dr Maldor's henchmen turn the Thermo-Dynamic Vibration Engine up to 'one hundred million volts', destroying the tall art deco building in which it is housed. Clouds of dust and falling debris are cut together with footage of a toy skyscraper collapsing against a darkened sky.

Even though he exists primarily as a projected image, Flash remains innocent of his name's true significance. Used by early photographers as a technical fix to capture an exposure in the quickest possible time, the flash is an instantaneous exchange between extremes of light and dark so powerful that it overwhelms sight. The reflective flare of a surface, the twinkling of stars and the bright flickering of sunlight are brought so unbearably close that they blind and distract the eye. Details fade. Reason and perspective are suddenly lost. The mechanics of the motion picture can no longer contain the forces they seek to depict. Cinema's most revealing trick, therefore, is to offer its audiences a convincing depiction of invisibility. Unseen hands brushing against people and moving objects around onscreen — this only works with a moving image.

In one of Flash's early adventures a strange machine causes him to fade away into invisibility. His enemies throw themselves about in empty rooms — doors open and things move around by themselves. However, it is not the moment of Flash's disappearance that fascinates so much as the slight moment of technical hesitation that occurs before it. An image's transition to a state of invisibility is never smooth — it exists as a fleeting, near-fatal uncertainty. What happens afterwards is, as a result, much easier to follow.

Once introduced, the illusion of invisibility continues to reproduce itself at unexpected moments. It takes on the nervous indifference of a pathological condition: seeing is no longer believing, but believing is now seeing. Through its efforts to convince by means of the mechanical play of light and shadow, cinematography achieves a collective form of madness, infecting everyone who sees it. The introduction of synchronised sound leads to the emergence of that which is unseen but can now be heard, thereby strengthening the illusion. The Invisible Man joins Dracula, Frankenstein, the Wolf Man and the Mummy as one of Universal's monsters. As well as their use of sound, these early horror films benefit from the

starkly experimental lighting effects brought over to Hollywood by directors and studio technicians fleeing Hitler's Germany. This is one of many ways in which America imports its modernism from Europe — the Nazis having little use for it.

Imprisoned inside a desolate tower in James Whale's 1931 adaptation of Mary Shelley's *Frankenstein*, the monster sees sunlight for the first time. In one of the most affecting scenes in cinema history, the manmade creature stretches out his hands to touch artificial studio lighting. That same year Bela Lugosi's performance as Dracula in Tod Browning's adaptation of Bram Stoker's novel brings an unseen erotic play to the transparency of film, light and shadow streaming through the pale mastery of his presence. Where Victor Frankenstein's creation invokes pathos, Bela's vampire count inspires sexual surrender. After the wild success of these two movies, Universal Pictures release several more monster movies — narratives dripping with bloody curses, weird science and the darkest exoticism. Each contains the kind of acting associated these days with porn stars: performed in an unlaboured sybaritic trance.

Bela Lugosi made a whole career out of disappearing. Among his many films are *The Invisible Ray*, *The Corpse Vanishes* and *The Whispering Shadow*. In *The Invisible Ghost*, his presence can be felt in the heavy static heard during a wordless sequence in which the body of his latest victim is discovered. In *The Phantom Creeps* he straps a 'devisibiliser' around his waist and fades into the background. Perhaps his greatest disappearance occurs in his last ever movie: *Plan 9 from Outer Space*, completed by Edward D Wood Jr. in 1956 but not released until 1959. Sick and old, caught in the unforgiving California daylight, Bela Lugosi is the movie's posthumous star, only appearing in test footage shot mere weeks before his death. Wood hired another actor, considerably younger and taller than Lugosi, to portray him as a ghoul haunting suburban Los Angeles with a vampire cloak held up over the lower part of his face to complete the far from perfect illusion that Hollywood monsters really do have an afterlife. This, however, is only one reason to watch Ed Wood's *Plan 9 from Outer Space* — there is so much to admire in one of the greatest midnight movies ever committed to celluloid. 'It's hard to find something when you don't know what you're looking for,' Kelton the Cop complains in one deathless scene, giving us yet another take on invisibility while he searches a graveyard at midnight. Flash forward from the early

serials to the horror fantasies of the space age, and Bela Lugosi's monochrome play of light and shade falls like a serene form of madness across the whole of 1960s Trash cinema.

'At last, something that doesn't vanish when you look at it,' an astronaut complains in 1965, confronted by the hostile world of Mario Bava's *Planet of the Vampires*.

Second Circle

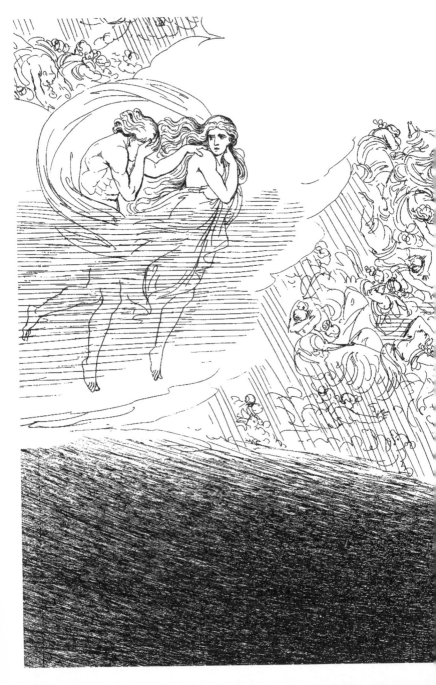

Caught up in the
carnal myth

Elegantly caped and attired as Count Dracula, Bela Lugosi watches a young blonde preparing for bed. A quick edit transforms him into a bat so that he can enter her room through an open window. Suspended from an invisible wire, there is something masturbatory about the way in which it jerks its rubber wings up and down. Returned to his original translucent form in the girl's bedroom, Lugosi leans down slowly over her exposed neck.

An erotic charge runs through Flash's adventures. As portrayed by former Olympic swimmer Buster Crabbe, Flash Gordon is a godlike and athletic figure whose person is constantly endangered: reduced at one point to a *jugendstil* motif of sexual suffering, stripped near naked and glistening with perspiration,

tortured in an atom furnace. Meanwhile his true love, Dale Arden, finds herself lusted after by beasts and alien rulers, even as her rival for Flash's affections Princess Aura struggles with her own heartless passions. Sex and death crackle around their youthful bodies like electromagnetic waves. The Emperor Ming radiates a cold prurient rage throughout his screen time; a coochie dancer straight off the boardwalk at Coney Island bumps and grinds for his pleasure, while gongs struck by impassive priests resound flat as tin trays. For Ming the Merciless, fake exoticism is the last resting place of absolute power.

Replicating itself endlessly, the Purple Death continues to spread across the Earth. Its tawdry exoticism can be detected in the films of Maria Montez, particularly *Ali Baba and the Forty Thieves* and *Cobra Woman*, both of which Universal released in 1944. Embodying a heady mixture of haughty glamour and sideshow burlesque, whether playing the princess of Baghdad or the imperious high priestess of Cobra Island, Montez is a petulant dream without equal, hailed by Universal Pictures as the 'Queen of Technicolor'.

Located outside time and space, somewhere over the spectrum, Maria Montez prepares to go into her Cobra Dance. In cinematic terms, the exotic becomes an unexpressed ritual of desires — 'the cobra ritual appeals to their emotions,' Maria Montez's mother says of the worshippers surrounding her daughter. The Second Circle of the Damned should be in full colour — for the most part. Dazzlingly bright and artificial, Technicolor maintains itself as an afterimage, overwhelming retinas long accustomed to fantasies played out in monochrome; and Montez remains its greatest exponent. *Cobra Woman* is directed by German cineaste Robert Siodmak whose first work for Universal was the black-and-white horror sequel, *Son of Dracula*.

••• ✚ •••

Everyone on Cobra Island says the word 'cobra' a lot, but no one pronounces it quite like Montez. As with Lugosi, her voice seems to emanate from another dimension, its cadences originating far beyond the shadows of this world. Even so, the faithful grow more unfaithful to their high priestess. Her gold tribute decreases each day. The fire mountain grows angrier. 'I demand more gold!' she proclaims to her worshippers. The Purple Death takes on the form of madness: the decomposed ecstasy of Trash. Nothing

makes sense anymore. Montez sits on her golden cobra throne flanked by handmaids in sparkling blue gowns and elaborate headdresses — smoking ritual bowls of poisonous green incense are arranged around them. Against a blue sky in the carefully-edited distance a plaster volcano releases a plume of smoke and flame from its craggy summit. Montez rises from her golden cobra throne, her monumental bejewelled headpiece echoing the spread of the cobra's flattened hood. 'I have spoken!' she cries. '*King Cobra!*' The damned souls return her invocation, giving the cobra salute with their right arms raised. To the clinking of her handmaids' finger cymbals, Maria Montez goes into her cobra dance. No one has seen a shimmy like this since the court of Ming the Merciless back on Planet Mongo, as she sets about arousing a rubber snake that lunges and coils in her presence. One by one she chooses her sacrificial victims. In gleeful possession the guards carry them off amidst screams and the sonorous banging of gongs.

Exoticism, exploitation and the dialectic of disappointment reach back to the moving image's earliest origins. They are present in James Joyce's 'Araby', written at the time of the first bioscopes with their flickering silent

V
Second Circle

reveries. 'The syllables of the word Araby were called to me through the silence in which my soul luxuriated and cast an Eastern enchantment over me,' the narrator recalls, summing up cinema's earliest appeal. The 'Eastern enchantment' turns out to be a banal fraud: a bric-a-brac sale in a church hall devoid of light and life, where 'only porcelain vases and flowered tea stands in the darkness' offer a hint of colour. It could be the interior of an actual cinema confronting the narrator at the end of the story. 'Gazing up into the darkness,' he confesses, 'I saw myself as a creature driven and derided by vanity; and my eyes burned with anguish and anger.' Even Maria Montez is not immune to this miserable exploitation of our dreams. She may well be 'the Queen of Technicolor' — but what kind of queen rules over an industrial colour separation process?

1.8.15 — Locarno: Under an oppressive summer sky we wander through side streets and silent courtyards. There is hardly anyone around. Up ahead an open-air film festival is in preparation, entirely covering one of the city's main squares — long uniform lines of yellow plastic chairs, all empty and pointing towards a gigantic white movie screen. Looks like a Nazi rally, R says,

gazing around her. Cinema exposing itself as a totalitarian medium: everyone in identical rows all facing in the same direction.

Did I really see as a child the Peruvian Yma Sumac rise singing from a volcano on the family TV beneath the fighting cocks — or did I just dream it? Exoticism in recorded music develops under the cinematic rule of the projected image synchronised with sound. With her five-octave voice, extended by an array of clicks, whistles, ululations, growls and vibratos, Yma Sumac fits right into Hollywood. Her voice capable of reaching ethereal heights and sensual, full-throated depths, Yma Sumac appears spiritual and elemental at the same time. Her record company consequently presents the singer as the divine incarnation of an ancient Inca bloodline as well as a nature spirit, capable of communicating with animals in their own language. Backed up by the lush production values of Los Angeles composer and arranger Les Baxter, her first album is a huge success. Yma is soon being driven around town in a pink and black Cadillac with gold wheels, while Woolworths sells 'Virgin of the Sun God' dolls in her image.

Each fragment in its relation to the whole is an evocation of the otherworldly: something to which a mass audience can only become accustomed by virtue of having witnessed it somewhere before. What is already known is barely noticed: it is the inclusion of the familiar rather than the strange that allows for the willing suspension of disbelief. The Purple Death as polychrome fantasy has never really receded from this world.

Trash makes a mockery of taste — it numbs expectations. In the end it can only be measured by quantity and excess.

Third Circle

Where the soul feasts upon filth

••• ✝ •••

A cartoon character of flesh and blood, Flash Gordon appears in crudely drawn parodies of his space adventures in several 'Tijuana Bibles': cheap pornographic comic books printed in Mexico and small enough to fold away inside wallets or hide at the backs of drawers. Everyone in these strips talks dirty and fucks furiously. In the final frame of 'Azura, Queen of Magic', the Witch Queen of Mars is tied down and tortured with a mechanical dildo while Flash gives Dale 'what she had many times begged for' on the laboratory floor. In 'Red Hot', Flash bends evil Queen Undina over a crate of 'the most powerful explosive in the universe', generating enough sexual heat to detonate it. His orgy with the Hawk Women only begins once they take off their wings because 'they get me nervous'. The cheap gluttony of the eye obtains maximum effectiveness — which is to say, maximum shamefulness.

With the introduction of Technicolor, the Purple Death infects everyone. Colour separation offers new forms of excess; processed, retouched and tinted, it transforms the surface of every movie it touches into an animated cartoon, where action unfolds in an ecstasy of priapic violence. The characters in Warner Brothers' Looney Tunes and Merrie Melodies series take the deepest pleasure in attacking and injuring each other. Living their lives at a velocity that flouts all laws of culture and nature, they cannot help themselves. Looney Tunes characters exist in a constant state of unpredictability. High-speed forces turn these creatures on; exaggerated bruises sprout from their battered heads like pineal erections.

An early master of exploitation cinema, Kroger Babb, buys the US rights to Ingmar Bergman's *Summer With Monika*, cuts it down from ninety-seven to sixty-two minutes to get to the film's nude bathing scene quicker, retitles it *Monica, The Story of a Bad Girl*, and releases it in 1955 with a new score and title song by Yma Sumac's Hollywood arranger Les Baxter. 'Continental' movies offer the promise of forbidden pleasures. 'Filmed in Sweden...a picture for wide screens and broad minds,' declares the poster copy before

adding, 'The Devil Controls Her By Radar!' The text's author, Babb protégé David F Friedman, is under no illusions about the movie's selling points: 'Nobody was buying Ingmar Bergman for his creativity or because he was a great film director, they were buying it because he showed some ass and some tits.' More people see *Monica, The Story of a Bad Girl* in the us than any other Bergman film. 'That's why so many adult theatres have the word "art" on them — they were art theatres,' Friedman explains. 'They became sex houses because the art theatres later moved more and more into the mainstream.'

American sex bares its flesh as a Technicolor dream. 'The new film school of Bergman-type film makers had better lift up their Freud-fraught sex symbols and run for the hills. An American film maker is hot on their tails with some "messages" of his own,' proclaims the press release for Russ Meyer's *The Immoral Mr Teas*. Even so, America's first ever 'nudie-cutie' is billed as a European import: 'A Frenchy Comedy for Adults' that parodies the grey wordless slapstick of Jacques Tati. Instead of hapless provincial Monsieur Hulot, the film concerns itself with the unguided wanderings of a Los Angeles bohemian as he delivers dental supplies on his

Ken Hollings: Inferno

American Flyer bicycle. A dreamer and a misfit, Mr Teas has the uncanny ability to see women in increasing stages of undress. Released in 1959, *The Immoral Mr Teas* establishes its director as an exploitation auteur with its dazzling colour, tight editing and crisp visual invention. Framed and paced more like an adult comic strip than the old 'naturist' movies, which had all the fun of an educational documentary, the narrative follows its hero to bars and offices, cafés and beaches, gas stations and bus depots. The film's American setting is an important part of its brash appeal. Meyer reveals Los Angeles as a piece of Pop Art waiting to happen. Monsieur Hulot suddenly finds himself a long way from home.

The nudes that Mr Teas encounters are nurses, waitresses and secretaries, offering American tits and ass without any art house profundities to get in the way. Dreams take over the action instead, starkly isolating the dreamer against a single-colour backdrop. A dentist extracts a red-and-white antler from Teas' mouth as a nude nurse looks on. A nude waitress busies herself at a table while the dreamer tucks into a huge red slab of watermelon. Each dream opens and closes with a spinning abstract spiral that fills the entire

screen. A cheap but effective cypher for madness and disorientation, it is a cinematic trick that brings Vienna all the way to LA.

A frowning young girl in a red pinafore dress is playing with a yellow hula-hoop in the front yard of a suburban home; she hurls a rock at the back of the dreamer's head. Mr Teas does nothing but squint back at her questioningly and then walks on. By the end of the movie Mr Teas is dashing to the psychoanalyst's couch, unsettled by all the naked flesh he has seen but is unable to touch. 'If frustration persists,' a voice on the soundtrack observes, 'modern man can at least be thankful for the advances in modern psychiatry.' Mr Teas' analyst turns out to be a woman reading a pornographic magazine at her desk. He soon finds himself confiding in a nude woman attentively poised over her pencil and notepad, which is the new American Dream at the dawn of the 1960s. 'On the other hand,' the voice concludes, 'some men just enjoy being sick.'

Cinematic lust is a deranged form of joy — a debasement of human emotion and the trashing of desire:

the movie does not represent this experience so much as have it for you. Sexploitation's projected arrangements of body parts are the phantom viscera of Trash Aesthetics. They are as inescapable as lust itself. All is suddenly dirty and undermines our dignity. 'You're a filthy liar,' a drunken Robert Stack spits at his slutty sister Dorothy McGuire in Douglas Sirk's *Written on the Wind*. 'I'm filthy *period*,' she snaps back.

Laughter without recognition is the primal mating call of the simpleminded. The success of *The Immoral Mr Teas* generates numerous copies and variations. Filmed in 'Cutie Color and Skinamascope', *The Adventures of Lucky Pierre* is released in 1961 just as the nudie-cutie is at the height of its popularity. Produced by David F Friedman and directed by Herschell Gordon Lewis, *The Adventures of Lucky Pierre* also has an urban wanderer encountering naked women wherever he goes, including a 'Drive-In Me Crazy' movie theatre, and serves up a version of the nude psychiatrist scene as well. Trash has all the failed sincerity of a vicious con trick. It leaves town with your money before you even notice it's gone.

✦✦✦ ✚ ✦✦✦

'Most people are making pretentious garbage,' David Friedman observes. 'I make funny garbage.' Thus spoke the cynic, and he is almost always right.

Fourth and Fifth Circle

Deep in the
swamp of passion

'Tura Satana', the exotic dancer, throws her long grey shadow over nudie-cutie hell — in her black leather jacket, avenging herself on the men who gang raped her at the age of ten, hunting down each one and telling him who she was before fulfilling her vow to get even with him.

Filth is a sensation let loose within a system and therefore destined to be defined by that system — and sensation is always that which forgets itself. Unresolved desires and frustrated prurience are forced to circulate, restlessly forming closed circuits and double binds: both of which are technical terms for a certain form of nostalgia. Experience condemns itself to live only in the past. This constant rechanneling exists as the un-

acknowledged expression of a collective mind: a form of image pollution that erodes the immediacy of the present. Running throughout exploitation cinema is the message that prurience undoes us — its presence creates fragmentation and an undifferentiated mixing of styles and perceptions. Exploitation, like all true Trash, deflects and evades our gaze. We cannot look directly at the cartoonish fleshy assemblies that are taking place without losing all sense of coherence. The separation and positioning of body parts, including the head itself, constitutes a social and cultural whole that appeared at first to be seamless but is, in fact, riven with fissures, cracks and breaks. It has nothing to do with desire but concerns itself instead with a shared nostalgia for what is forbidden.

'Man Discovers A NATURE CAMP On The Moon!' screams the poster copy for Doris Wishman's *Nude on the Moon*; but what the movie actually reveals is a topless community of space aliens, complete with antennae, living in Coral Castle: an architectural folly built in Florida by a lonely eccentric over the first half of the Twentieth Century. The Moon Creatures lead an idyllic naturist existence amid its utopian courts and grottoes sprinkled with seashells and plashing watercourses.

VII
Fourth and Fifth Circle

The colour photography suggests that a low-budget Cobra Island has been established on the Moon to the repeated melody of a cheap pop tune. One of the few women making exploitation movies at the time, Doris Wishman hides her identity behind the name Anthony Brooks in the credits.

Exploitation is a crisis of representation: a leering approximation of experience. Everything is a cheap copy of something that has been forced out of existence by a creeping dialectics of disappointment. It marks the corruption of belief. The promise of a thrill becomes more important than the thrill itself. Wishman's film has two rocket scientists drive around colourful feeder roads, planning their Moon Mission in motel rooms and offices, blasting off from a child's playground in identical spacesuits. 'Don't forget we're rocket scientists,' one warns the other when he finds himself falling in love with the Queen of the Moon People. Back on Earth the scientist discovers, via a crudely executed dissolve, that his secretary is the topless incarnation of the Moon Queen. This effect is another clumsy take on cinema's disappearing act: instead of vanishing, the face and body are shifted slightly through space as they change over

time — now you see them, now you see them again, only slightly misaligned. Technical considerations are the least of anyone's concerns at a moment like this. This constant copying is a distraction. It has its own power but displays none of the creative spontaneity to be found in true desperation.

Frustration and prurience create violent soap operas out of their victims. Wishman's films revel in the awkward implications of this awareness. 'You're waiting for me to talk,' Doris Wishman announces to an interviewer, 'but I really have nothing to say.' What the eye registers as purple is actually an excess of light. Overblown, affected and exaggerated, it constitutes the worst kind of imagery.

'We were naïve enough to hope for the look of a Bergman film and the feel of Cocteau,' Herk Harvey confesses of *Carnival of Souls*, his independently produced black-and-white horror fantasy released in 1962. Embedded in an American landscape of highways, churches, rooming houses and department stores, the focus of this creeping nightmare of a movie is 'Saltair',

Fourth and Fifth Circle

a deserted amusement park located on a stretch of white Utah lakebed. The park's main pavilion with its strange minarets and Moorish towers stands silhouetted against the twilight, an abandoned domestic Baghdad, when Harvey drives past it one evening. He stops the car and 'transported into a different time and dimension' walks out onto the desolate causeway to take a closer look.

Carnival of Souls begins with the most adolescent of rites: a drag race on a stretch of open highway. One of the speeding cars swerves off a bridge into the muddy tides of the river below, taking all three of its female occupants with it. Only one of them, a young woman called Mary Henry, manages to struggle ashore, apparently the sole survivor of this tragic accident. Mary's subsequent attempts at a normal life, however, are constantly disrupted: she finds herself either haunted by white-faced ghouls or completely ignored by the living. To be unseen and unheard in a movie also means to become a projected hallucination for the audience. A victim of the same techniques that make people disappear or cause women to become suddenly nude, Mary appears to be slowly losing her mind.

Caught between a swollen muddy river and a dry salt lakebed, *Carnival of Souls* is a movie whose entire logic plays with themes of invisibility. Confused reactions at a preview screening persuade Harvey that the results 'were a little too far out for the time and place', condemning his movie to play in shortened form on the Southern and drive-in circuits before disappearing completely.

The white-faced ghouls in *Carnival of Souls* go into a high-speed dance, jerking and spinning around a darkened ballroom in a mechanically engineered parody of romance. They swarm beneath the Moorish towers of Saltair, crowd into Mary Henry's waking life — occupy all of the seats on the Eastbound bus leaving town from Gate 9. Like any true piece of exploitation cinema, *Carnival of Souls* reveals America's popular culture to itself in strange and disturbingly new ways. Sporting both a girl's first name and then a boy's, Mary Henry exists in an undifferentiated condition outside of time. She talks to a psychiatrist, like any true American in the early 1960s, but he turns out to be yet another ghoul. Monsters serve as warnings of either what is to come, what might have been or what once was. 'It was like a science fiction movie,'

VII
Fourth and Fifth Circle

Henry Geldzahler will tell Andy Warhol, 'you Pop artists in different parts of the city, unknown to each other, rising out of the muck and staggering forward with your paintings in front of you.'

Sunk deep in its own swamp, writhing with ghouls and zombies, Manhattan quickly becomes the new Cobra Island.

Fifth and Sixth Circle

From the River Styx to the Capital of Hell

During the summer of 1962 Jack Smith films his epic fantasy *Flaming Creatures* on the roof of the Windsor Theatre, reputed to be the oldest picture house in New York. This Lower East Side mausoleum to the movie industry serves as set, dressing room and property department for what *Playboy* will describe as a 'faggoty show reel' where 'everything is shown in sickening detail, defiling at once both sex and cinema'. Paradise is hard to see through eyes no longer accustomed to seeking it. *Flaming Creatures* is shot without sound on the cheapest black-and-white stock under the exposed glare of the sun.

···✛···

A performer, theatre director and visionary poet, Jack Smith understands the uncompromising splendours of

disappointment and despair. Beneath his silent gaze, Manhattan becomes a second Baghdad: caught between the East River and the Hudson rather than the Tigris and the Euphrates, and ruled by the Queen of Technicolor herself. Maria Montez presides in effigy over an audience of drag queens, underground actors and filmmakers; and among her worshippers Jack Smith serves as High Priest. The fake orientalist splendour of Maria Montez's films, together with their lush over-scored soundtracks, represent a magnificent lost paradise to Smith and his circle: an artificial Eden located outside the stale, repressed bankruptcy of modern culture. Films like *Cobra Woman*, *Tangier* and *Siren of Atlantis* point towards a condition of flickering innocence that endures, inviolate and magical, within a cinematic reality of its own devising. The ramshackle title sequence for *Flaming Creatures* is accompanied by over three minutes of gongs, drum rolls and voices lifted from the soundtrack for *Ali Baba and the Forty Thieves*. It is through such false grandeur that Smith's film 'echoes with ancient ritual chant,' according to an early review, 'a paean not so much for the Paradise Lost but for the Hell Satan gained.'

Caught between Paradise and Hell, Smith's silent creatures are spirits trapped in painted flesh and thrift-store

ball gowns: some have lipstick and whiskers pushing through pancake makeup, others have breasts swelling beneath tattered black lace and cheap costume jewellery. Some of them dance — others pose. None of them can escape the camera — nor would they want to. In Oscar Wilde's *The Picture of Dorian Gray*, its main character witnesses a poorly staged production of Shakespeare in an East End theatre. 'It was a tawdry affair,' Dorian idly remarks, 'all Cupids and cornucopias, like a third-rate wedding-cake.' He may as well have been describing scenes as they unfold on the roof of the Windsor Theater.

An animated cartoon of the flesh, *Flaming Creatures* takes place in its own collapsed time and space. The amount of marijuana, speed and cocaine consumed by the cast during the summer's rooftop filming does not fix things any more precisely. Smith and his intimates stoke themselves up on anything from camphor-based drugstore remedies to hallucinogens. For all the lengthy preparation of costumes, makeup and masking, there is no sense of a coherent ritual developing onscreen: instead the gestures and dances and interactions show signs of being carelessly fractured through the editing and sequencing — a slapstick

mime unfolds according to the random dictates of the soundtrack. '*Today!*' hisses a voice from nearly twenty years before. '*Ali Baba comes today!*'

Most of the *Flaming Creatures* soundtrack is derived from a discarded selection of 78s, including the rhumba 'Amapola', an old Cuban crooner 'Siboney', plus the Japanese ballad, 'China Nights'. Also adding colour and contrast to the mix are the Kitty Wells country number, 'It Wasn't God Who Made Honky Tonk Angels', Bartók's *Concerto for Solo Violin*, plus the Everly Brothers' 1960 cover of Gene Vincent's rockabilly classic 'Be-Bop-A-Lula'. Thrift-store gowns and second-hand music have a liberating effect. Avant-garde composer Tony Conrad works on the *Flaming Creatures* soundtrack, using tape loops to create the crescendo of screams and moans that accompanies the film's infamous 'Earthquake Orgy'. The cinematic effervescence of this sequence takes possession of the screen without warning or fanfare — not as the film's climax but at an unexpectedly early stage in the proceedings. Over rolls of thunder and the ecstatic cries of men and women come showers of plaster dust spilling onto a sprawling mass of body parts: mostly flaccid cocks, wrin-

kled scrotums, jiggling breasts and splayed thighs. Hands and fingers gently grope and prod an array of wobbling protrusions and floppy swellings.

Bodies become a series of detached parts held together only by the pose. Even when characters are shown dancing either alone or with each other, an activity that takes up the remainder of the film, these actions display a lack of connection between the participants. Every other body seems unfamiliar to both partner and participant in the dance, occupying an unfocussed cinematic arena made up of painted backdrops and misty, emulsion-flecked faces. Foreground, costumes and backcloth merge together. As always, Trash is about taking what you can get where you can get it: an end to the established habits of recurring pleasure. Immature and unformed, Trash will never be anything other than itself. 'Juvenile does not equal shameful and trash is the material of creators,' Jack Smith declares. 'It exists whether one approves or not.'

There is an innocence to *Flaming Creatures* that has nothing to do with the habitual responses of taste

or decency. It disarms by setting itself against the banality of the commercial world: demolishing the old glamour of Hollywood cinema, probably the most enticing consumer item of all, even while seeking to emulate it. The 'defiling' of sex and cinema that upset *Playboy* so much is the casual knockabout at the heart of *Flaming Creature*'s structure. Sexual identity is deliberately blurred — treated as an irrelevance. These are creatures, after all — we might try to photograph them, but there is always the fear that they might simply disappear. 'It took place in a haunted movie studio,' Smith says of the film's setting. 'That's why those people were coming and going like that.'

At first glimpse *Flaming Creatures* is a random sequence of moving images, bleached and grey and innocent, imprinted on semen: ectoplasmic visions of body parts. What happens to belief when such moments are repeated? Its orgies and defilements are located outside that industrialised amalgam of written and spoken words which is the Hollywood shooting script. *Flaming Creatures* maintains itself as an ecstatic ritual that opposes language. Tension alone brings this film to life. The accumulated habit of scripted and repeated behaviour establishes itself as a mechanism that contains

sexual frenzy, allowing all rituals to end safely — or as Jack Smith will later phrase it with consummate irony: 'a clean movie studio is a happy movie studio.' Only the movies can capture these creatures intact.

'Don't run down dyed hair and painted faces,' Lord Henry Wotton admonishes Dorian Gray. 'There is an extraordinary charm in them, sometimes.'

Sixth Circle

The perversion of
the innocent

'Art is the mathematical result of the emotional desire for beauty,' Oscar Wilde declares from Paris in 1883. 'Any moment,' Jack Smith replies from Manhattan nearly eighty years later, 'America will arrive at scientific reasons for aesthetics.' And what possible reason could either of them have to be wrong? Aesthetics has always implied an excess of sensation.

··· ✚ ···

Released in 1962, *Pages of Death* has long been thought a lost film: introduced by former pro footballer and sports broadcaster Tom Harmon, it concerns the disappearance of eleven-year-old Karen Flemming, 'the kind of little girl that you have in your family or would like to have.' Two investigating detectives uncover her body in a ditch at the city dump, their arrival accom-

panied by the main title theme from Ed Wood's *Plan 9 from Outer Space*. 'Murdered?' one of them asks. 'Sex fiend,' replies the other. This short film, produced by the *Hour of St. Francis* radio programme and distributed by the Citizens for Decent Literature, argues that there is a direct correlation between the increasing availability of obscene publications and the rise in horrific juvenile crime. Karen Flemming's killer is a high school student with a collection of books, magazines and photographic slides hidden away in his den. 'Hey, look at this,' one police detective says to other as they go through the kid's possessions without a warrant. '*Scorching Sex Stories...Shows All, Tells All...Night of Horrors...Home of the Stripper.*' He almost purrs. His partner holds up another offending publication. 'Strictly hard core,' he concurs.

Some of the libidinal furies of the flesh can be glimpsed leering from the covers of men's action and adventure magazines, readily available at drugstores and newsstands. Typical *Man's Life* stories from the period include 'Death Fight for Love at Slaughterhouse Brothel', 'The Nationwide Shame of Teenage Sex Clubs' and 'Trapped in the House of Nazi Dagger Girls'; *Man to Man* offers 'Bullets for a Naked Nympho'; *For Men Only* goes with 'Kill and Run Nude'; *Wildcat Adventures*

promises 'Death Orgy of the Leopard Women', 'Mad Dogs and the Naked Cuties' and 'Branded Nudes of the Teen Jungle'; while *Man's Story* features 'Beware the Peril of the Female Sex Criminal', 'Back Alley Kicks of the Teen Sex Cults'; and *All Man* leads with 'I Acted in a Nudie'. The lurid artwork for all of these stories is attached as a kind of visual exclamation point.

'You know what pictures like this can cause? Sex maniac headlines! Murder! Some characters will steal or kill just to get this stuff,' rages police detective Kenne 'Horsecock' Duncan in Ed Wood's *The Sinister Urge*, made just two brief years before *Pages of Death*. Bondage pinups and violent pornography are turning the nation's youth into a generation of psycho killers. The investigating detectives look on stone-faced.

The indulgences of childhood prepare for the idiocies of the adult world. To enter adolescence during the early 1960s is to participate in a mode of consumption that makes itself conspicuous as Trash. Unfamiliar myths and legends start to form themselves: adolescent desires are defined by what is forbidden.

Ken Hollings: Inferno

In 1962, Topps releases *Mars Attacks*, the latest in its bubble-gum card series. Boasting the kind of lurid horror imagery banned by the Comics Code Authority since 1954, this particular set of cards depicts an attempted Martian invasion of the Earth dreamed up by *Mad* cartoonist Wallace Wood and painted by men's adventure magazine illustrator Norman Saunders. The story is told through curdled images of violence and death rendered in the erotically hallucinogenic detail of male fantasies. Saunders is also responsible for the slick, ultra-realistic painting of half-naked women in bondage being doused with gasoline to accompany 'Soft Flesh for the Nazi Monster's Pit in Hell' on the front cover of the November 1962 issue of *Man's Story*.

Back in *Pages of Death*, the two detectives go down to the corner bookstore where Mr Baker peddles smut from behind his counter. 'It's not a skid row operation anymore,' one says to the other. 'These kids can pick up these girlie magazines and sex violence stuff all over town.' Mr Baker simply grins at them, a box of Kleenex Tissues nestling on the shelf behind him. The detectives accuse him of putting within the reach of kids 'smut that we wouldn't allow in the city jail because it's too strong for hardened criminals.'

From the kids' perspective, the Martians in *Mars Attacks* are pretty hep: they pilot big and powerful spaceships, operate giant robots and fire death rays that strip the flesh off human bones, set giant spiders on people and even kill dogs. Card number 17 in the series, 'Beast and the Beauty', shows a Martian crashing through a bedroom window to drag a startled young female from her bed. On card number 21, 'Prize Captive', a terrified blonde in a red dress is being wrapped in the arms of a grinning Martian predator. The creatures' large round eyes, bared teeth and exposed brains hint at an anatomy of decay — as if a covering layer of skin has been peeled away to reveal heads that are coming apart while remaining intact at the same time. Only their transparent space helmets and green pressure suits appear to hold the Martians together. Incomplete, unstable and yet bursting with barely repressed energy, these cartoon monsters give themselves up entirely to gleeful destruction. Increasingly nervous about the reaction of parents and teachers to the *Mars Attacks* cards, Topps list a fictitious company, Bubbles Inc., as the manufacturers. Topps also ask Norman Saunders to repaint fourteen of the more extreme scenes, including 'Beast and the Beauty' and 'Prize Captive' to tone down their violent eroticism. In 'Beast and the Beauty' Saunders replaces the startled female in her nightdress with a portrait of himself sporting a mous-

tache and a pair of yellow pyjamas with blue piping. But with teenage America so willing and eager to rot both its teeth and its morals, Topps eventually decide to stick with the original card designs, their visual kick being reserved exclusively for childhood's darker incarnation: the adolescent.

Young bodies and minds generate a negative spectral energy. The juvenile inevitably drags culture down: first as someone to be protected from 'adults only' smut, then as the consumer of cheap and disposable Trash. Tom Harmon addresses the camera once more at the conclusion to *Pages Of Death*: 'Statistics show that sex crimes have increased in the same ratio as the obscene publication racket. J Edgar Hoover has said that sex-mad magazines are creating criminals faster than we can build jails to house them: 75 to 95 per cent of obscene material winds up in the hands of children.'

Kenne Duncan in *The Sinister Urge* can only agree: 'Show me a crime, and I can show you a picture that coulda caused it!'

Sixth Circle Continued

Inside the burning
tomb of flesh

'Mothers of America,' the American poet Frank O'Hara exhorts, 'let your kids go to the movies.' Such dark exposure will lead them happily to 'the glamorous country / they first saw on a Saturday afternoon' or perhaps even 'their first sexual experience'. The unhappy alternative, O'Hara argues, is that 'your children grow old and blind in front of the TV set / seeing / movies you wouldn't let them see when they were young.' Teen passions, cheap pop tunes and even cheaper movies make for highly volatile yet easily disposable sensations.

The teenage bedroom becomes the refuge for a new self: a half-formed ghoul playing with monsters and machines, establishing an identity for itself out of spare parts. This, after all, is the first generation to

learn how to play with plastic. Dracula, Frankenstein's Monster and the Wolf Man strike dramatic poses in Aurora's 'All Plastic Assembly Kit' series; their bases and settings hint at the thrill of darkness and decay. Plastic, however, does not decompose: it only gets dirty, scratched and scarred. It does not cancel itself out or disappear from the world but is overlooked and discarded instead. Sold in boxes with garish cover art by heroic painter of American scenes James Bama, each model kit allows teenagers to own Universal's most famous monsters. There is a mass appeal in the endless replication of hardened and hollowed-out clichés. Adolescent rebellion is assembled out of such trivia. Lenny Bruce performs a stand-up routine about kids getting high off plastic model kit glue. The stuff drips from grey metal tubes, sticks to your fingers, forming a brittle and transparent second skin.

To come into being, to be defined, is a grubby business — especially in its earliest stages. Self-determination is an undifferentiated form of violence: taste and virtue have nothing to do with it. In 1963, Andy Warhol completes a silkscreen portrait of Bela Lugosi as Count Dracula about to bite a blonde woman's neck and calls it 'The Kiss' — not only do the purity

and danger of the vampire myth become a form of Pop Trash but the currents of lust and desire swirling around it are similarly transfigured. Warhol claims to live only on blood — and candy.

'The film opens with that fake sphinx outside the Suez Motel,' Herschell Gordon Lewis says of his 1963 release *Blood Feast*. 'And then we start pouring blood all over the place.' By 1963 the nudie-cuties are no longer packing them in the way they used to. Slowly replacing them are the 'roughies': movies that directly link sexual display to bloody violence. Produced by David F Friedman and shot on location in Miami Florida, *Blood Feast* plays well in the Southern states, traditionally considered a good market for exploitation movies. Having watched the market for nudie cuties diminish, Friedman and Lewis offer their audiences something that Hollywood is not yet prepared to give them — even the film's title appears in dripping red letters. 'Teenage Girl Found Slaughtered — LEGS CUT OFF!' screams the headline in *The Daily Chronicle*, while grim announcements on the radio warn young women not to go out unaccompanied after dark. 'Well, we're just working with a homicidal maniac — that's all,' murder squad detective Pete Thornton lamely ad-

mits to his partner. Except that this particular maniac is called Fuad Ramses, has authored a book called *Ancient Weird Religious Rites* and keeps a temple dedicated to the Babylonian goddess Ishtar in the backroom of his 'Exotic Catering' store. Meanwhile the cops have no clue as to why 'certain limbs and organs have been removed' from the murdered young women — 'looks like one of those long hard ones,' remarks detective Thornton enigmatically. In this movie actors speak and behave as if they are caught up in a dream, mesmerised by the words that appear to issue involuntarily from their mouths.

That which becomes erect is also hard and lifelessly hollow in cinematic terms, like an aroused showroom dummy, whereas the liquefying of wounds and bruises opens up flows and streams. Bodily damage is frighteningly alive in a way that engorged genitalia are not. In *Blood Feast* young women have their brains and tongues cut out, are abducted and flogged to death or have their hearts pulped and cooked. 'Have you ever had...an Egyptian Feast?' Fuad Ramses asks startled suburban matron Dorothy Fremont, staring at her from beneath his grey-streaked eyebrows. She wants to throw a party for her teenage daughter Suzette,

and an ancient celebration of the goddess Ishtar as performed by the Pharaohs of old sounds like marvellous fun. The local epicures are sure to come running.

'Well I'd better get going,' Suzette perkily announces back at the Fremonts' ranch-style home. 'Tonight is the weekly lecture on ancient history. We're learning about cults of the Egyptian gods.' Her mother looks surprised: 'Did you say Egyptian gods?' Meanwhile back in his secret temple, Ramses is busily cooking up female body parts in tribute to Ishtar, who looks down at him from her shrine: a gilded mannequin in heavy lipstick and eye makeup, festooned with cheap costume jewellery and swags of blue cloth. With its heavy red drapes, sacrificial altar and golden goddess, the temple of Ishtar is a tightly controlled cinematic space within the movie. A windowless sepulchre, its walls keep Fuad Ramses strictly separated from the world outside — a featureless sprawl of swimming pools, shops and offices, pink flamingos, garden furniture and hostess telephones. Within its lightproof confines, sadism, mutilation and the preparation of human remains become part of a violent drama that has been played out, so the story goes, for over five thousand years. From her earliest days in Babylon,

Ishtar has always been the goddess of love, war and sexuality, renowned for treating her lovers cruelly. 'Hers was an evil love that thrived on violence,' concludes the public lecture on the Egyptian gods that Suzette has rushed to attend. 'I don't want you out on the streets at night — not with all this terrible killing going on,' her mother blandly remarks before insisting that Suzette get a ride home. Detective Thornton, who happens to be her boyfriend, is happy to oblige, although 'you might be safer with the killer than you are with me,' he adds, evidently having read too many men's adventure magazines.

'*Blood Feast* is an accident of history,' Herschell Gordon Lewis subsequently asserts — but which history? Lewis and Friedman return with Eastmancolor gore in the form of *Two Thousand Maniacs!* and *Color Me Blood Red*. Thanks to them, splatter establishes itself as an aesthetic rather than a genre, fake blood becoming one of the trashiest materials in existence. On the run from the police and far from his secret temple, Fuad Ramses is mangled to death in the back of a North Miami Beach sanitation truck.

'He died a filthy death — like the garbage he was,' sneers a homicide cop. A final cutaway shows Ishtar, alone on her altar, weeping bright red tears of loss.

Sixth Circle
Concluded

Kicking and screaming through the Underworld

··· ✟ ···

Billed as 'Master of the Terrifying' and responsible for such cheap shockers as *I Was a Teenage Frankenstein* and *How to Make a Monster*, Herbert L Strock comes up with *The Crawling Hand* in 1963 — introducing 'Sex Iceberg' Sirry Steffen, shown wiggling into a bikini at the movie's start. Sharing the beach with her is the severed arm of an astronaut who has been blown up in space by Mission Control after he turns into a sweating maniac screaming 'Kill! Kill!' into his radio receiver. Sirry's boyfriend does the normal thing and takes the arm home, where he keeps it in the refrigerator. Under the limb's psychotic spell, he quickly changes into a hollow-eyed killer. Meanwhile kids hanging around the local roadhouse listen to 'The Bird's The Word' by doo-wop outfit the Rivingtons. The close harmony group scored a huge hit in 1962 with the song: a smooth play of nonsensical put-ons

— because 'everybody knows that the bird is the word'. The record is still playing on the jukebox when the roadhouse manager gets choked to death by Sirry's boyfriend in one of the movie's more violent scenes.

It is, in its own modest way, a defining moment. This violent blend of teenage weirdness, alien horror, classic roadside Americana and a catchy tune is endlessly replicated across low-budget movies from the early 1960s onwards. Also released in 1963, Ray Dennis Steckler's *The Incredibly Strange Creatures Who Stopped Living and Became Mixed-Up Zombies!!?* is billed as the 'first monster musical' — the film's creepy action interspersed with half-hearted dance routines set to beat instrumentals, Connie Francis-style ballads and sedate teen dance numbers like 'Shook Out of Shape' — there is even a carefully choreographed nightmare sequence taking place in an empty nightclub. *The Incredibly Strange Creatures* has its own dream logic. The main action takes place inside an ever-expanding labyrinth of cocktail lounges, sideshow attractions and penny arcades. Steckler includes a number of actual carnival rides, giving his movie a raw kinetic energy, as if the amusements themselves are getting violently out of hand.

'Filmed in Terrorama and Eastman Color,' *The Incredibly Strange Creatures* tells the rather abstract story of Jerry, a young LA drifter played by Steckler himself under the name 'Cash Flagg'. He falls under the sadistic spell of Madam Estrella, a Mexican fortune-teller with a booth on the midway of a local carnie. First seduced by Estrella's sister, an exotic dancer at 'The Hungry Mouth' nightclub, Jerry is hypnotised with the aid of a spinning spiral very similar to the one glimpsed in Russ Meyer's *The Immoral Mr Teas*. Pretty soon he is in a homicidal trance, stabbing burlesque dancers in the face and trying to strangle his girlfriend. No reason is ever given for these attacks — nor is it explained why Madam Estrella pours acid on men's faces, transforming them into hideous zombies, before locking them in a closet at the back of her booth.

If Meyer's *The Immoral Mr Teas* revels in Los Angeles as a piece of American Pop Art, Steckler's *The Incredibly Strange Creatures* celebrates film as American folklore. 'Whenever there's a carnival I'm there,' Steckler confesses. 'Whenever there's gypsies, I'm there. When I was a little kid I was always around them. Ferris wheels, anything like that — that's for me.' In early screenings of the film, Steckler arranges for mutilated zombies to

leap out at the audience during key scenes. 'We Dare You to Remain Seated when Monsters Invade Audience!' runs the tagline for these special midnight spook shows. Steckler himself enjoys playing one of the monsters until a customer tries to shoot him — after which he decides to stop being a zombie.

Steckler had travelled from New York to Los Angeles to work as a cameraman on Timothy Carey's *The World's Greatest Sinner*, his first movie job in California. Carey had acted opposite Marlon Brando as an outlaw biker in *The Wild One* and shared a scene with James Dean as a whorehouse bouncer in *East of Eden*. He also starred in the early 'roughie' *Bayou*, a lurid and violent melodrama of sexual tension set in the Louisiana swamplands. The film was later bought back from the distributors by its producer, M A Ripps, who cut in some explicit nude scenes, plus a shot of Carey getting an axe embedded in his back, and reissued it as *Poor White Trash*. Over the next ten years, the movie plays picture houses throughout the Southern states, earning Ripps an estimated $10 million. At the same time Carey plays a gangster in a relatively late nudie cutie, *The Mermaids of Tiburon*, shot in 'Aquascope and Eastman Color' and starring *Playboy* centrefold and 'Queen of the Nudists' Diane Webber. This

movie is also recut to incorporate additional nudity and later reissued as *Aqua Sex*. Meanwhile a portion of Ripps' profits from *Poor White Trash* is invested in Timothy Carey's own film project *The World's Greatest Sinner*.

Never properly completed, Carey's Trash masterpiece premieres at the Wiltshire Theater in Fullerton, California in 1962. To introduce the movie Carey fires a handgun over the audience's heads: the resulting fistfights spill out onto the street. Despite his inability to find a distributor, *The World's Greatest Sinner* steadily builds up a cult following through midnight movie screenings in Los Angeles. Written, directed and starring Tim Carey, the film tells the story of Clarence Hilliard: a frustrated insurance salesman who is inspired by a rock-and-roll show to start his own religion. Changing his name to 'God Hilliard', he proclaims that 'There's only one god, and that's man!' Pretty soon he is fronting his own rock revival review. 'We should be gods, every one of us here — super human beings!' Hilliard yells at his enthused audience as he writhes around onstage in a glittering pimp's suit. Founding his own political party, 'The Eternal Man', he then takes a swing at the presidency. 'Testing the boundaries of his holiness,' according to one early account of this film, 'Hilliard has sex with a

92-year-old woman then steals her money, beats up his daughter, sleeps with a 14-year-old acolyte and forces another guy to kill himself.'

Ray Dennis Steckler's credits after *The World's Greatest Sinner* include camerawork on Arch Hall Sr.'s *Eegah!*, a 1962 drive-in novelty featuring a giant caveman wandering in from the California desert and causing havoc at a local country club. Sharing the screen is teenage beat combo Arch Hall Jr. and the Archers, fronted by Hall's son. That same year Arch Hall Jr. stars in Steckler's *Wild Guitar* as a naïve pop performer who roars into Los Angeles on a motorcycle only to be ruthlessly exploited by the entertainment business.

Steckler plays Hall's psychotic showbiz minder: a nervy bundle of boredom and homicidal rage called 'Steak'.

XII
Seventh Circle

The River of Blood

Regarding the cruelty
of bestial intentions

In the summer of 1963 *Cleopatra*, 'the movie the world has been waiting for', is released. Its producer is Walter Wanger, the man responsible for starting Maria Montez's Technicolor career at Universal — and who once, mad with rage, shot his wife's lover in the groin and thigh while he was leaning against the hood of her car. Andy Warhol notes how all the young girls in Brooklyn are styling themselves after Liz Taylor in the film: 'long, straight, dark shiny hair with bangs and Egyptian-looking eye makeup.'

In a fundamentally disappointing universe of illusions, the motion picture industry becomes a machine for playing back the masses to themselves — and the masses have no idea what they are looking at. A plague

of glamorous, alluring zombies is let loose upon popular culture: mindless and unstoppable in their course. While Ray Dennis Steckler is filming amusement park rides on the California coast, movie magus Kenneth Anger relocates from LA to the Eastern seaboard, focussing his lens on members of a Brooklyn motorcycle gang, framing them against the carousels, sideshows and boardwalks of Coney Island. Since 1962 Jack Smith, Andy Warhol and members of their respective circles have been making the journey out to Brooklyn to visit this late Victorian diversion situated beside the Atlantic Ocean, drawn by the fading ghosts of popular entertainments and attractions once haunted by the teeming masses. Like the abandoned minarets of Saltair, stranded by its dry lakebed, Coney Island is a second Babylon, where the bodies of thieves, suicides and lovers are washed ashore daily.

Containing hidden shallows, Trash always exceeds itself, knowing how to go exactly too far. The carney sideshow and the amusement park ride define the close swarming of the masses in the age of popular culture; similarly, a combination of rock music and low-budget moviemaking offers a shadowy refuge in the age of television. The independent US filmmaker becomes the folk artist

of the late industrial age. Kenneth Anger's *Scorpio Rising* mythologises the bike gang as 'Thanatos in chrome and black leather and bursting jeans', elevating it above the engine parts, cement floors, boots and chains caught on camera. 'It's all reality,' Anger will later claim. 'In other words, I didn't change what I found there.'

The dramatic focus of this myth is discharged US Marine and Korean War veteran Bruce Byron, who was turning tricks and sleeping in movie houses on Times Square when Anger discovered him. As 'Scorpio', Byron is an ungainly beast, first glimpsed lying on his bed reading the funny pages; Anger frames him among comic-strip panels cut from *Peanuts*, *Dick Tracy* and *Li'l Abner* for their latent scenes of violence, death and homoeroticism. With their boyish arms around each other, two cartoon hoodlums with wild hairstyles press their faces close together. 'So how come our folks hate each other?' one asks the other. A sharp-edged Trash poetry accumulates around Scorpio at the centre of his room: pinups of James Dean, badges, rings and ornaments, news clippings describing fatal motorcycle collisions, pages torn from *Mad* magazine; glowing and grainy bluegrey images of Marlon Brando in *The Wild One* flicker on a nearby TV set. These images are all surface — their

saturated colours have an acidic dazzle to them, especially when reflected in polished chrome and gleaming motorcycle parts. One early critic describes the visual action of *Scorpio Rising* as 'the ultimate reduction of ultimate experience to brilliant chromatic surface... artificial death'. Reflections and glowing screens on film only emphasise how every movie that exists does so as an 'artificial death' for its viewers, drugging and mesmerising them and then stealing their souls — which is to say, their time.

Cinema pulses like an open vein. Astrologically, Scorpio is the ruling sign for sex organs and machines. Presiding over their conjunction as film, Kenneth Anger has referred to *Scorpio Rising* as 'a death mirror held up to American culture.' Running parallel to its reflected glory is a soundtrack made up of songs by the likes of Ricky Nelson, the Crystals, the Angels, Little Peggy March, Elvis Presley, Ray Charles and the Surfaris. The hypnotic and dissembling power of music — in other words, its ability to evade comprehension — allows a culture to hide from itself. 'Plastic', both as a cheap, disposable commodity and as something that can be endlessly repeated without revealing anything more than a continually revolving surface, pop's 45 rpm repetitive beat

is best understood within the subterranean confines of the movie house during the early 1960s. Timothy Carey twisting and writhing around the stage at a rock-and-roll prayer meeting in *The World's Greatest Sinner* is eloquent testimony to that. The frenzied all-embracing totalitarianism of the music, together with the reverent submission it inspires in its audience, provides the perfect soundtrack to violence, madness and sex.

Masquerading as the new exotica, technology is experienced as a form of cultural primitivism. In 1963 the Kingsmen climb the charts with a spirited but incoherent version of 'Louie Louie', resulting in an anonymous complaint being forwarded to the Federal Bureau of Investigation. 'We all know,' claims the unnamed high-school tattle-tale, 'there is obscene materials available for those who seek it, but when they start sneaking in this material in the guise of the latest teen age rock & roll hit record these morons have gone too far.' The combo's rendering of the lyrics to 'Louie Louie' prove so impenetrable that the record requires several months' analysis in an FBI laboratory, where it is speeded up and slowed down in order to ascertain whether indecent words or phrases can actually be heard. Two years later the bureau can report that since 'the lyrics of

the song on this record was not definitely determined by this Laboratory examination, it was not possible to determine whether this recording is obscene.' Unintelligible at any speed, or so the FBI claim, 'Louie Louie' may be the first pop 45 in history to have someone shout the word 'fuck' before the instrumental break — but you'd really have to want it.

It takes the Trashmen, a landlocked surf band from Minnesota, to attain the total collapse of meaning in 1963 by splicing 'The Bird's The Word' with another old Rivingtons hit, 'Papa-Oom-Mow-Mow', to create the sublimely incomprehensible 'Surfin' Bird'. The two songs are joined at the centre by a babbling unaccompanied vocal free-fall so deranged it appears to have interfered with the actual recording process, distorting the sound of the pop 45 rpm forever. It is a breath-taking moment: the music suddenly stops, and the singer hurls himself into the phonemic depths, stammering and spluttering his way through a tumbling range of vowels and dropped consonants. What gives this vocal plunge a last technological kick is the way the studio engineer jerks the tape on the vocalist's last exhausted inhalation, making it jump and buck perceptibly.

✦✦✦ ✚ ✦✦✦

Machines and sex organs become ecstatically con-
joined — as if 'Louie Louie' had been compressed into a
perfect moment of gleeful incoherent rage.

XIII
Seventh Circle

The Suicides

When God's nature is torn apart and defiled

••• ✝ •••

Nothing impedes the forward momentum of Anger's bikers, urged on by *Scorpio Rising*'s soundtrack. No other direction but straight ahead is possible, the record changer insists. No other end is possible except violent oblivion. The death mirror reflects only those willing themselves to die. Accompanied by scenes from a Sunday School movie depicting the final days of Jesus Christ, Scorpio quits his room for a Halloween party with the other bikers, then breaks into a deconsecrated church — a motorcycle race ends in a fatal accident, and the screen fills with swastikas, pictures of Hitler and red lights. Each song introduces a separate episode: a reminder that Anger was influenced by Flash Gordon movie serials during his childhood, claiming Flash Gordon as a personal hero — ahead of decadent poet the Comte de Lautréamont, the inventor of fantastic cinema Georges Méliès and occultist Aleister Crowley.

Pop music is a harangue delivered straight to the listener: every song ever written will eventually wear its audience down. You stop listening. Warhol painted while relentlessly 'blasting the same song, a 45 rpm over and over' until he 'got it'. Pop lyrics merely constitute the carrier signal: the actual content of any song is the sound it makes, not the sense. The song constantly repeated at 45 rpm establishes a mood rather than a meaning: its form compressed to the point where it begins to resemble content. 'The music blasting cleared my head out,' Warhol revealed.

The disappointment that glamour leaves in its wake can only be diminished by making others believe that it is in fact genuine and always has been. This elated tragic vision can be found in Ron Rice's *Queen of Sheba Vs. The Atom Man*, Ken Jacobs' *Blonde Cobra* and Andy Warhol's *Tarzan and Jane Regained... Sort Of*, shot in Los Angeles during the summer of 1963.

15.4.07 — Breakfast with Ken and Flo Jacobs near the hotel, it was a fine spring morning. 'To reanimate history is to lie', Jacobs says — he worked

XIII
Seventh Circle: The Suicides

with Jack Smith until 1962. 'The future?' Jack had said. 'The future will be worse.' Flo talks about being arrested at St Mark's Place during the police raid on a screening of Flaming Creatures *for saying it was a beautiful film — this in reply to a NYPD vice cop who had said it was a despicable piece of trash — which indicated that she had seen the film — she was on the door taking tickets at the time, not in the audience for the screening — another woman with her 'said she only took the money so she was OK — they left her alone.'*

On March 3 1964 at the New Bowery Theatre at 4 St Marks place, New York police seize a copy of Jack Smith's *Flaming Creatures*, arresting Jonas Mekas, Ken Jacobs and Florence Karpf, plus the projectionist and the theatre manager. The visual frenzies of *Flaming Creatures* are declared obscene in New York Criminal Court and become the subject of considerable judiciary scrutiny. 'That movie was so sick I couldn't even get aroused,' an anonymous United States Senator complains after a screening on Washington's Capitol Hill. Ken, Flo and Mekas receive suspended sentences.

Five days later, on 7 March 1964, the manager at the Cinema Theatre in Hollywood where *Scorpio Rising* is playing gets arrested and charged with 'lewd exhibition.' The film's 'Walpurgis Party' sequence featuring the drunken Halloween antics of the Coney Island bike gang had come to the attention of the police. At the ensuing trial, a series of twenty-five blown-up stills showing the bikers bearing their buttocks to each other and exposing their penises — including one thrust through a hole cut into a life-size cardboard skeleton — is shown to an all-female jury. The jurors are unanimous in returning a guilty verdict. Vice cops and state prosecutors see no appreciable difference between exploitation and underground 'art' movies. All is defiled and defiling in their sight. *Scorpio Rising* had been playing the Plaza Art burlesque house in Chicago. 'The theatre offered it as a headliner in a "Something for Everyone" package,' according to one account. 'Supporting films included...one of Radley Metzger's soft core imports from France for straights, *The Fast Set*. A bunch of strippers, the Plaza Playmates, supplied the live entertainment.' A party is always a party.

When copied often enough, what was cool and hip in the beginning is now trashy, intense and inane but

also touched by a genius all of its own. The copy is always alive with imperfections, deviations and lapses. It continually mutates, allowing successive generations of misshapen hopeful monsters to come into being. Kenneth Anger's Walpurgis Revels are repeated as a series of cheap imitations in teenage horror and sexploitation movies until well into the next decade. According to Robert Smithson, the sculptor Peter Hutchinson 'will go to see a movie on 42nd Street like "Horror at Party Beach" two or three times and contemplate it for weeks on end.' Fine Art and Trash have yet to look each other squarely in the eye, however. Del Tenney's *The Horror of Party Beach*, to give the movie its correct title, is released in 1964. It follows Steckler's *Incredibly Strange Creatures* in billing itself as 'The First Horror Monster Musical', inviting audiences to 'Hear the big-beat sound of the Del-Aires swingin' with the beach party set!' Filmed on the East Coast, this is a surfer movie without surfboards. Partying teens try to have fun in the sun while being terrorised by 'Weird Atomic Beasts' from beneath the sea. 'Some kind of monster's killing people and drinking their blood,' one of three girls in a convertible murmurs pensively. 'Imagine being that thirsty,' deadpans the girl sitting next to her. 'These creatures are human bodies kept alive by radioactive decay,' resident atomic scientist Dr Gavin reveals, as mutants resembling

angry flesh-eating artichokes attack slumber parties, showroom dummies and drunk drivers. Ignoring the danger, the kids dance on, make out in the sand and rumble with a local bike gang, played by members of the Charter Oak Motorcycle Club of Connecticut. 'The question in *The Horror of Party Beach* is which is more horrible — the monsters or the rock 'n' roll?' asks *The New York Times* after being subjected to the Del-Aires' 'Zombie Stomp'.

'It's a human thing, Dr Gavin,' claims Eulabelle, the atomic scientist's black maid. 'It's a human evil thing lurking and creeping and crawling around out there in the night. I know it. I feel it.' All repression is rational. 'For your protection! We will not permit you to see these shockers unless you agree to release the theater of all responsibility for death by fright!' runs the movie's trailer. 'Get your fright release when you enter the cinema.' A production still from *Scorpio Rising* shows Kenneth Anger posing in full leather by 'The Reaper', a chromed and gleaming show bike, watched over by a life-sized death figure draped in black.

The fuel tank is spray-painted a bright candy shade of lavender because, as Anger explains, 'lavender is a colour of mourning.'

The Burning Desert

Blasphemers craving Heaven's attention

••• ✝ •••

One summer in the early 1960s, a bunch of young surfers grabbed some cheap boards and rode the storm drain that ran for about a mile beneath the coastal town of Windansea right down to the beach. What made the gesture memorable was that they were decked out in Nazi regalia: armbands, helmets and medals brought back from World War II and liberated from family closets. This was the kind of antisocial behaviour expected of young surfers at the time, and they did their best to meet all expectations. Cartoon character Hot Curl, created by Michael Dormer, is the ultimate surfer: a small wave-riding teen monster, shaggy blond wings covering his entire face, obscuring both himself and the world. 'We did things to be outrageous,' surf legend Greg 'Da Bull' Noll later revealed. 'You paint a swastika on your car and it would piss people off. So what do you do? You paint two swastikas.'

The ultimate teen passion is to get gone: to keep moving, above all, and to merge with the distant horizon. From coast to coast, drag racing rivals surfing as the defining youth pastime, while the beach is submerged under an incoming toxic tide of exhaust smoke and burning rubber, grey primer and lacquer fumes. The Beach Boys perform live on TV flanked by gleaming hot rods. Jan and Dean and Dick Dale join them in recording tunes celebrating hot rods, roll bars and shifters. Producer Gary Usher assembles car songs using a pool of musicians under a shifting number of names. His masterworks include 'Dracula's Deuce' and 'Little Old Lady from Transylvania' by the Ghouls.

The hot rod becomes a stripped-down personal statement, a 'set of wheels' that connects the suburban garage with the highway, and the factory assembly line with the junkyard. In its purest form, it can be any car made before 1934 with its hood and fenders removed: the vehicle of choice being the '32 Ford, the original 'Deuce Coupe', with its powerful V8 engine milled from a single block of aluminium. All extraneous details, such as running boards and wing mirrors, are gone; roofs 'chopped' to smooth out their profile; and the entire vehicle lowered on its frame by cutting out and raising the

floor. Cars are often 'raked', with the largest tyres possible on the rear wheels and much smaller ones up front, while flat aluminium hubcaps are fitted to improve the line. Automotive individuality is in. Customising rules. Modification is the teenage form of modernism.

Losing your life after being challenged to a spontaneous drag race by some stranger idling at a stoplight becomes the industrial apotheosis of freedom. Panicky newspaper headlines denounce kids for staging late-night races. Then come the high-school screenings of blood-spattered driver's educational films such as *Red Asphalt*, *Mechanized Death* and *Wheels of Tragedy*, using actual footage of car wrecks, together with the bloody remains of their human victims. Just as these go into compulsory rotation, Andy Warhol creates a series of silkscreen paintings, including *Saturday Disaster* and *Ambulance Disaster*, based upon raw newspaper photographs of auto collisions, bodies hanging out of the twisted metal.

One radical figure to emerge from the underground world of outlaw car culture is legendary pinstriper Von Dutch. Born Kenneth Robert Howard, the son of a Los

Ken Hollings: Inferno

Angeles sign painter, Von Dutch starts out as a motorcycle mechanic but is soon working in the shop of legendry car customiser George Barris. It is here that he first pinstripes a car to cover up the grinder marks on one of its doors. The process involves rendering freehand an ultrafine mesh of lines to enhance the bodywork, the resulting effect being fiercely symmetric and intricate. Striping brushes are thin 'daggers' that come to a tiny point, lightly tracing a filigree of matter and space, emphasising a car's weightlessness. Everything is static and in complex motion at the same time. Circles are bisected and divided, ellipsoids elongated, triangles multiplied and overlaid.

Another of Von Dutch's innovations is the flame job: a graphic rendition of flames licking off the bodywork, making the car appear as if it were in motion even when stationary. The flame job is the depiction of matter transformed instantaneously into energy; clear and exact and yet also fleeting to the point of absence — the perfect emblem of outlaw 'kustom kulture', it offends in order to disappear. Von Dutch understands this to a mythic degree. 'Everyone got mad at me,' he says of the time he once flamed a Mercedes Gull Wing. 'They thought I had desecrated a shrine!'

A thrill killer strangles women at night, leaving a lipstick cross scrawled on his victims' foreheads. Suspicion falls on local hot rod gang the 'Fastbacks' in zero-budget psycho shocker *Teen-Age Strangler*, shot in Huntington, West Virginia and released to widespread public indifference in 1964. The only clue to his identity is a frightened witness's glimpse of a black leather jacket bearing the Fastback emblem. The hot rod gang is shown driving their parents' open-top sedans in some of the tamest chase sequences ever committed to film. Kids hang out at the neighbourhood fast food joint, dancing to a song called 'Yipes Stripes', while the strangler prowls the darkness. Yipes Stripes 'make your waistline smaller'; apparently, 'it's the latest craze to hit the town'. The creepy high school janitor is finally unmasked as the killer.

Von Dutch is one of the first to airbrush grotesque forms and apparitions onto items of clothing, especially T-shirts. From deep within the grease pits of machine culture, he brings cars and monsters together in paintings and designs that turn the lightweight tangle of pinstriping into a bloody merging of metal and flesh. He paints a portrait of a man forcing himself through a meat grinder and carefully fades the message 'Fuck You' into a specially commissioned artwork. Just as the chroming of parts

creates reflective surfaces projecting invisibility even when the car is motionless, these aggressive distortions are a way of disappearing — a way of simply being 'gone'.

While teenagers in their thousands take to kustom kulture, Von Dutch withdraws from public view, choosing to live in an old bus fitted with its own workshop. 'I don't want to be known as a personality' he declares; and his active avoidance of fame perplexes a culture that is fast becoming obsessed with it. The Von Dutch logo is a signature based upon an assumed name made up of eight letters, none of which is repeated, and yet the rhythm and symmetry of the arrangement identifies its creator immediately. Similarly, the 'flying eyeball', which he devises as a personal motif, is a reduction of the human presence to a veined and unblinking eye sprouting wings. He claims that the origins of this symbol can be traced back to Ancient Sumeria.

A statue of cartoon surfer Hot Curl, sculpted out of concrete, gazes out to sea from San Diego's Windansea Beach, an actual beer can in his fist.

The Phlegethon

Violence against taste and good order

Kustom kulture is an extension of the road in other forms. Decals, T-shirts, dolls and plastic kits are more than accessories — they are the bright continuation of an automated space, reaching into bedrooms and high schools. Teen America is, above all else, an urban structure.

Much more publicly visible than Von Dutch is Ed Roth. Another native of Southern California, he was taught pinstriping by Bud 'The Baron' Crozier from the Studebaker production line. 'I grew up in darkness,' Roth confesses, 'spending most of my time in darkness or with a broken brushful of putrid paint trying to figure out what combination of sickly colour and sicker ideas would "snazz" up the worthless heap of trash that was currently sitting in my driveway.' Roth later picks up on the aristocratic affectation of 'Von Dutch' and 'The Baron' by sporting a top hat, tuxedo and monocle at public appearances. He styles himself 'the man you love to hate', a product of America's eternally misplaced highway.

Roth's deliberate self-deprecation as misfit or monster can be traced back to the acerbic satire of *Mad* magazine, which started out as a spoof horror comic just as the originals were being pulled off the newsstands. His fame rests upon the custom cars he creates to his own designs from automotive junk; sleek fibreglass bodies, space age Perspex domes and innovative detailing come together in futuristic visions such as the 'Beatnik Bandit', the 'Orbitron', the 'Outlaw' and the 'Mysterion'. The kids come to see these unique creations at car shows and stay in line to buy his T-shirts. Airbrushed by Roth himself, these often feature some slavering bug-eyed monster at the wheel of a savage hot rod. 'Being the obnoxious and rebellious types that Americans are,' Roth explains, 'we gravitate toward art, music, haircuts and clothes that say, like "I'm Cool" or "I'm a Big Shot". That's the kind of social statement that my T-shirts provided.' The introduction of silk-screening ink and Plastisol ensure that his designs reach an even wider teenage audience.

17.4.06 — Got to Santa Pod around 11, walked past the monster trucks and the Wall of Fear, which still hadn't opened, old Indian motorcycles stacked up outside. Had a great day

XV
Seventh Circle: The Phlegethon

in the stands, despite the weather: a lot of jet cars, a rocket bike powered by hydrogen peroxide, but the guy riding it was wearing the most ridiculous helmet, a cartoon duck head painted on it. They were running fuel altereds, trying to establish them as a class, not actually racing them, just giving points for burnouts and acceleration times. One was a 1960s classic with nerf bars. The light in the morning was beautiful but went grey and sour by late afternoon: reduced to hanging round the back of the grandstand, drinking coffee and eating donuts — saw the most beautiful rainbow over the fields, against a steel-grey sky. The final run was between a top fuel dragster and a funny car. Both came apart on the finish line — the funny car was in flames and the dragster just disappeared into a mass of sparks. By then the sun was going down and you could see the exhausts flaring.

Less confrontational than Von Dutch's brutal grotesqueries, Ed Roth's monsters are ultimately quite endearing; their eyeballs may flop around inside their rancid skulls and their tongues dangle over broken teeth from

the sides of their mouths, but they share the same eagerly explicit prurience as Tex Avery's Screwy Squirrel, Looney Tunes' Porky Pig, Bugs Bunny, Foghorn Leghorn and Daffy Duck. They constitute an almost pornographic form of renegade fun. As Roth's popularity grows during the 1960s, his monsters and fancy custom cars are brought together in a series of plastic assembly kits from Revell, who are also responsible for giving Roth the nickname 'Big Daddy' to make him more appealing to the kids. As an affectation 'Big Daddy' may not seem that aristocratic, but it has a trash authority that goes well with the top hat and the monocle. Gary Usher also brings Big Daddy into the recording studio, releasing the results as the work of 'Mr Gasser and the Weirdos.'

Exoticism is another form of technology: a mode of perception far too complex to be grasped in ideological terms alone. Things that seem overtly 'exotic' are assumed to exist within an absence of class and taste, erasing social distinctions on their surface and yet enforcing an inverted elitism upon those who would become their admirers. In the words of Georg Lichtenberg: 'It is impossible to have bad taste. But many people have none at all.' Little daily acts of violence against discernment continue to multiply.

✦✦✦ ✟ ✦✦✦

The outlaw semiotics of kustom kulture starts to proliferate in popular culture, inscribing itself onto its immediate environment. Ace car customiser George Barris oversees the building and design of the ornate hot rod hearse and the coffin-shaped 'Dragula' seen in *The Munsters*, a comedy series produced by Universal to exploit their copyrighted Dracula, Wolf Man and Frankenstein makeup effects. The show's setup has a blue-collar family of monsters living in a suburb of Southern California, where their attempts at leading an outwardly conventional life only lead to fear and panic. It's always a dark and stormy night over at the Munsters' home. 'This was such a nice neighbourhood until *they* moved in,' a female neighbour complains in an early episode, her nerves aroused. She's erecting an electric fence between her house and theirs. 'Those Munsters are not running me off my property,' she explains. 'But I don't want them wandering over here, if you know what I mean.' Every viewer in white suburbia knows exactly what she means. Placing the weird and the exotic in the midst of the American ideal is a particularly strong theme in 1960s television comedy. ABC's *The Addams Family* gets its laughs from a similar premise: a household of rich eccentrics whose inverted values give them a gothic allure while terrorising everyone else. The Munsters meanwhile are shown constantly kiss-

ing each other. 'We're a very old family,' Lily Munster insists. 'You're right, dear', husband Herman Munster agrees. 'It's not as if someone just dug us up yesterday.'

The road leads forever to the beach. Details of a Michael Dormer surfside mural, showing bug-eyed monsters, giant gorillas, aliens and bearded beatniks, appear in the opening credits to *Muscle Beach Party* featuring a Les Baxter soundtrack and recurring visual references to Hot Curl. Ed Roth designed the lopsided hat worn by the movie's wipe out surfer 'Deadhead'. Journalist Tom Wolfe hails Roth as the 'Salvador Dali' of kustom kulture. 'Von Dutch used to say "That Salvador Dali is okay,"' according to Ed Roth.'"He likes my work but I could never repay the compliment."' Roth also claims that 'years and years of watching wrestling' have taught him everything he needs to know about the art world.

'What mean booble gum?' Salvador Dali asks when presented with a forty-pound chunk of the stuff at a publicity event.

The Waterfall

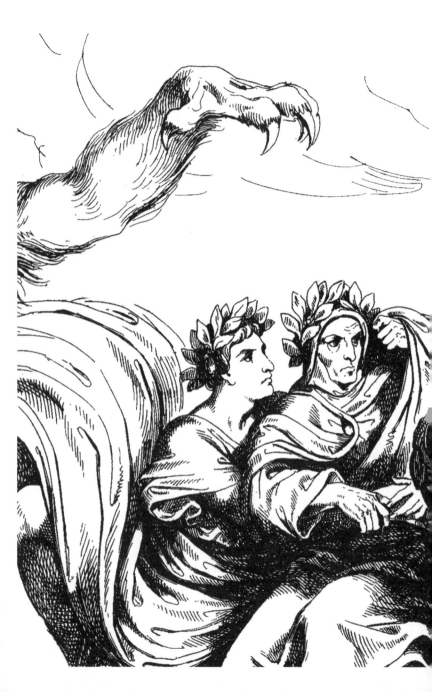

Running between
the quick and the dead

Our eyes betray us — but always after the fact, which is unsurprising in a culture devoted to speed and acceleration, shifting experience between the teenage and the adult.

Who is finally at the wheel? Rat Fink, Ed Roth's most notorious creation, appears to palpate space with his protruding eyeballs — bloodshot, veined and tumescent, they barely fit inside his leprous head, hunched forward in the driver's seat of a powerful hot rod. Sketched on a restaurant napkin while Roth was railing against Walt Disney's bland corporate designs, Rat Fink is essentially 'Mickey Mouse turned inside out': a grinning, scabrous creature in a pair of red overalls, the 'R.F.' scrawled across its swollen belly in a parody of the Superman logo. 'It had a strange power over me,' Roth said of the sketch. 'Whenever I looked at the drawing, I felt I was looking for the first time at reality — my reality. The world that my parents, teachers and

responsible type people all around me belonged to wasn't my world. Why did I have to be like them, live like them? I didn't. And Rat Fink helped me realize that.'

Sweating, socially maladjusted and inept, his skin breaking out in scabs and spots, Rat Fink is the apotheosis of the male adolescent: grimacing and twisted by anguish. The words 'rat' and 'fink' are terms applied to the lowest orders in both the underworld and the schoolyard: they indicate a snitch or a liar — someone who cannot be trusted. Looking like a piece of vertical road kill, his hands clasped behind his back, Rat Fink bares needle-sharp teeth in a self-deprecating smile — his likeness spreading rapidly across auto shops, high-school lockers and bedrooms. He is childhood's imagined end. His manic stare is fixed upon a traumatised fantasy of adulthood, of what lies ahead: the crazed monster at the wheel of a powerful racing machine. Now you see him — now you don't.

'Bad-taste entertainment is the best entertainment,' enthuses Lawrence Alloway of New York's Guggenheim Museum, referring to Walter Keane's portraits of chil-

XVI
Seventh Circle: The Waterfall

dren who, in contrast to 'Big Daddy' Roth's adolescent rat, seem quite literally dead. Keane paintings focus upon the depthless black holes of their large eyes. Reproduced across millions of posters and postcards, the Keane waif is a creature that consumes itself with its own frozen sight. Its isolated gaze reveals that the eyes are the background to the soul — the rest of the face, from its receding cheeks to the shaded point of the chin, remains an emphatic blank. Famous Keane clients include Kim Novak, Robert Wagner, Joan Crawford, Liberace, Zsa Zsa Gabor — and the Pavilion of Education at the 1964 New York World's Fair.

'World's Fair Pavilion Selects Theme Painting' runs a headline review in *The New York Times* for 21 February 1964. *Tomorrow Forever* is to be Keane's masterpiece. One hundred sad-eyed children flow in a racially diverse cascade from the distant horizon down darkened steps that look like railroad ties towards the viewer: the faces collectively capture the imagined ravaging of a world after war. The prospect proves too much for the *Times* art critic John Canaday. 'This tasteless hack work contains about 100 children and hence it is about 100 times as bad as the average Keane,' he writes. Meanwhile Walter Keane's dead grandmoth-

er appears to the painter in a vision. Michelangelo, she reveals, has put his name up for nomination as a member of art's elect inner circle, saying that *Tomorrow Forever* 'will live in the hearts and minds of men as has his work on the Sistine chapel.' Dr Nathan Dechter, chairman of the board of directors for the Pavilion of Education, shares a similar opinion. 'What is desirable is what really pleases the mass public,' he says in defence of Keane's painting. 'In other words,' sniffs Canaday 'the function of education is to determine the lowest common denominator and see that it is maintained.' If, the critic continues, 'some mass-public product, say bubble-gum had chosen the Keane picture as its theme' then that might be another matter. As it is, *Tomorrow Forever* is quietly removed from public view. 'Let's face it,' Walter Keane boasts to *Life* magazine, 'nobody could paint eyes like El Greco, and nobody can paint eyes like Walter Keane.' Except that his wife Margaret has actually been painting them — all of them — in secret.

'I think that what Keane has done is terrific,' Warhol tells *Life*. 'It has to be good. If it were bad, so many people wouldn't like it.' The article in which this quote appears characterises Keane's paintings as contributing to the 'bric-a-brac of Early Space Age America'. But

XVI
Seventh Circle: The Waterfall

nothing in the future ever goes to plan. At the start of the New York World's Fair, Andy Warhol is asked to remove his painting *The Thirteen Most Wanted Men*, featuring FBI posters of current criminal fugitives, from the 'The Tent of Tomorrow', otherwise known as the New York State Pavilion. Like Keane's *Tomorrow Forever*, the organisers are worried that it will cause offence. Warhol instructs the panels to be sprayed over with silver paint — 'and that'll be my art,' he says. The following day *The New York Times* reports on the high number of robberies at the Fair.

The wider the eye, the greater its ability to capture things in a world of lidless speed — the eye becomes the event. Large eyes are a prominent feature in the work of Japanese cartoonist Osamu Tezuka, who had adapted this defining feature from character designs by Disney rival Max Fleischer. Tezuka's most famous creation, Astro Boy the child robot, boasts eyes so large that they double as spotlights. That which is cute can also be truly disturbing. Astro Boy is the creation of a scientist father, made in the image of his dead child, killed in an auto collision: a barely suppressed secret that haunts the series. NBC buys the US rights for Astro Boy's animated adventures, making it the first of

several Japanese series to be shown during the 1960s. Astro's knockabout antics prove too much for NBC, however, who quickly drop him from their schedule.

Cuteness and irresponsibility breed their own violence. The coincidence of limitless destruction with wide-eyed cartoon innocence makes death and disaster no one's specific responsibility — least of all the juvenile viewers. A permanent flash of light is reflected back from a hard and shiny pupil that adult eyes cannot penetrate. Norman Saunders follows up the bug-eyed horrors of *Mars Attacks* with ranges of cards that accurately chart adolescent trends for the 1960s. As his son David recalls: 'Topps and Norm Saunders continued to collaborate on an incredible variety of gum-selling products, most of which reflected popular trends on kiddie TV: Batman! Monster Valentines! Ugly Stickers! Nutty Initials! Rat Fink! Mad Foldees! Insult Cards! Monster Alphabet! Groovy Names, Flower Power Alphabet! I can't remember them all...'

No wonder Andy Warhol produces most of his early paintings and films in a place called 'The Factory'.

The Drop

Monsters that rise
from the depths

··· ✦ ···

A new mythology comes into existence, presided over by the greatest siren of them all: more exotic even than the Queen of Technicolor. 'The Empire State Building is a star,' Andy Warhol announces in 1964. 'It's an eight-hour hard on. It's so beautiful. The lights come on and stars come out and it sways. It's like Flash Gordon riding into space.' While the visual frenzies of *Flaming Creatures* and *Scorpio Rising* are declared obscene by a shocked judiciary, Warhol's silent eight-hour-and five-minute epic *Empire* sprawls itself alluringly across the silver screen. Thanks to Warhol, you can look at it for as long as you like: a permanent erection captured on film. Flash Gordon is back in his rocket ship. Intended as Warhol's first sound movie, shot with a 16mm Auricon, *Empire* is released without a soundtrack. The slow gathering and unpicking of the light occurs in a state far removed from the intense audio-visual noise generated by the huge amounts of amphetamines being consumed by the Factory's wide-eyed denizens. Exposed film slowly

trashes itself in the light. A phallic object that can be appreciated in the abstract, the Empire State Building exists as a timetable not a structure — its actual erection required a careful regime, a constant flow of materials and manpower delivered in the right order: which is to say, at the right time.

Camp exposes the displacement of human emotion by its cinematic counterpart; celebrating the impossibility of glamour in a tawdry world, it reads strange new subtexts into the old Hollywood melodramas of fake beauty and fake suffering. The exotic becomes a continual exercise in nostalgia: which is to say, escape. As playwright Ronald Tavel remarks about scripting Andy Warhol's movies at the Factory: 'A person whose work is as much about escaping as mine and whose entire compulsion is exoticism and whose favourite actress is Maria Montez must have a very clear understanding of the here and now they want to get out of. It was this here and now that he was interested in...' Nostalgia is the group expression of an undifferentiated collective mind. A theatre without a stage, Camp holds groundless sway over the world to the extent that it no longer appears either natural or unnatural.

In 1964 Susan Sontag publishes her 'Notes on "Camp"' in *Partisan Review*. It is a text that will never escape the quotation marks contained within its title. 'Camp', Sontag argues, has so far evaded being named because it is a sensibility rather than an idea. Best understood as a way of looking at things rather than a thing in itself, 'Camp' functions as a negative medium: a critique. 'To name a sensibility, to draw its contours and to recount its history, requires a deep sympathy modified by revulsion,' she observes. 'Notes' implies the kind of ironic detachment from the depiction of an emotion that is finally required in order to rediscover it. 'Notes', after all, are merely observations that have been registered but not fully considered. Events, the note-taker seems to suggest, are happening far too quickly for any other response. 'Notes' also hints at a lack of participation in the phenomenon oneself: an uptown mentality peering down at the trashy and hip goings-on below. They have been written, Sontag claims, for Oscar Wilde.

That same year, the July issue of *Esquire* publishes 'The New Sentimentality': a montage of film stills and captions assembled by David Newman and Robert Benton in an attempt to define the mood of the

decade. The Old Sentimentality of 'Patriotism, Love, Religion, Mom, The Girl' is disappearing in favour of the coolly appraising intellectual gaze, characterised by an ironic and remote sensibility. There is a will to shock rather than be shocked. It is now a matter of maintaining your cool in an increasingly high-speed electronic age through overt displays of indifference and a refusal to be moved. 'Love gets in the way and ruins the scheme,' Newman and Benton observe when writing about television violence. They speak strongly in favour of 'Kicks for art's sake.' All emotion will eventually kill itself. Desire is cooled down to the point of numbness.

As spectators, the masses begin to consume themselves. The public has no idea what is appearing before it. Rising up alongside Antony and Cleopatra are James Bond, Batman and the Beatles. David Newman and Robert Benton are responsible for scripting the Hollywood movie *Bonnie and Clyde* and the stage musical *It's a Bird...It's a Plane...It's Superman*. They list Lenny Bruce, Audrey Hepburn, Roy Lichtenstein, Jean Shrimpton, Malcolm X and Timothy 'God Hilliard' Carey as representatives of the New Sentimentality. Irony often expresses itself as a restless weariness

of the senses. Everything revolves endlessly around what you *don't* really mean. According to Newman and Benton, 'one of the definitions of The New Sentimentality is that it has to do with you, really just you, not what you were told or taught, but what goes on in your head, really, and in your heart, *really*.' That third 'really', emphasised in the original, suggests just how deeply that ironic detachment can run. 'A typical Warhol dilemma, that word "really"', one critical account remarks of Andy Warhol's early films. 'One can just hear the word crawling from the mouths of the Factory denizens: she didn't really say that, we didn't really do that, they don't really believe that.'

Among the examples listed by Susan Sontag to illustrate her notion of Camp, the last to be included is 'stag movies seen without lust' — and nothing really destroys lust quite like irony. Independent distributors of underground and art house movies handle 'nudie cutie' reels for a more demanding audience who know how to pay for their pleasures. In fact, art house and underground productions may also fit the bill if there is a chance of them supplying a cheap erotic thrill. 'Now beauty can be a terrible thing,' Kenneth Anger observes, 'beauty can be twisted and abused. I under-

stand it within myself and try to reflect it outward in my work.' In this twilight world of 'pasty' attractions, to borrow one of Jack Smith's favourite terms, Sontag's 'stag movies seen without lust' maintain an ambivalent presence. The point at which irony tips over into cynicism is what marks the difference between underground and exploitation movies — the connection can, in fact, only be made cynically. Trash is a bourgeois nightmare: it represents a gratification not so much deferred as denied to the point of becoming a tangible presence. The willing submission to socialised arousal becomes a form of bad faith. They don't call them 'exploitation movies' for nothing. Manners and perceptions transform casual indifference into an article of faith. Trash is the outcome: in so many words, an act of confession. Between them, 'The New Sentimentality' and 'Notes on "Camp"' outline an emerging sensibility that appears modern and hard-edged to the point of sarcasm.

Trash is the violence that seethes just beneath the cool, impassive exterior of both.

The
First and
Second Gullet

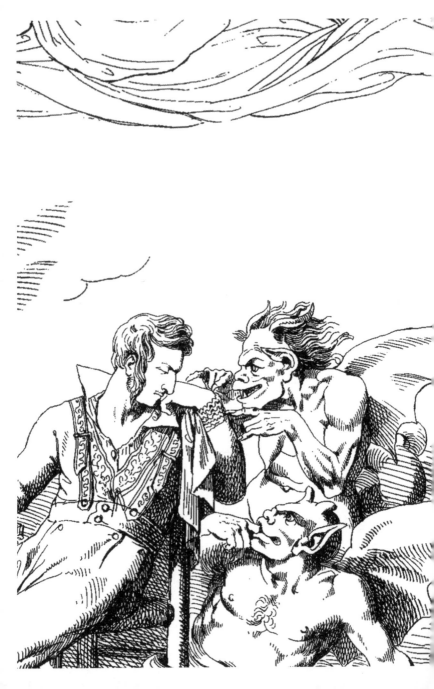

The Beautiful, The Bloody and The Bare

··· ✝ ···

The Amazing Criswell, television psychic and philosopher of the main chance, rises majestically from his coffin. He is wearing a black satin vampire's cape that once graced Bela Lugosi as Count Dracula in Universal's *Abbott and Costello Meet Frankenstein*: an encounter few have ever survived. 'This is a story of those in the Twilight Time,' Criswell announces, 'once human, now monsters in a void between the living and the dead. Monsters to be pitied! Monsters to be despised! A night with the ghouls!' Popular culture decrees that capes are worn either by superheroes or predatory corpses. The mark of the vampire, the most human of all supernatural creatures and therefore the most disturbing, is imprinted upon the minds of the masses. Based on a script by Edward D Wood

Jr., *Orgy of the Dead* is a 1965 sexploitation burlesque featuring Criswell as a cruel Ming-like 'Emperor of the Dead' presiding over a retinue of go-go dancers and recognisable movie monsters such as the Mummy and the Wolf Man. Ed Wood's childhood friend John Andrews plays the latter. As youths, Ed and John used to act out scenes from Flash Gordon serials with the neighbourhood kids. 'Everyone wanted to be Flash,' Andrews recalls. 'Not Eddie. Eddie had no competition...he wanted to be Dale!' While working on *Orgy of the Dead*, Criswell sleeps in his coffin between takes.

Trash's true depths are only revealed when it is taken literally: an act of understanding that requires the greatest imagination. *Orgy of the Dead* is a reworking of Jack Smith's *Flaming Creatures* set on a haunted Los Angeles soundstage, where monsters and topless beauties come and go in 'gorgeous and shocking' Astravision and Sexicolor. Nudie cuties, especially the later ones, require colour — and lots of it. Ed Wood started out calling his screenplay *Nudie Ghoulies*; then the producer A C Stevens changes it to *Ghouls and Dolls*. Criswell later suggests *Orgy of the Damned* before Stevens finally settles upon *Orgy of the Dead*. The titles alone tell the story.

As well as appearing in *Orgy of the Dead*, the Wolf Man and the Mummy are seen performing alongside the Cobra Woman, the Mermaid and assorted vampires and 'Cuties' in Jack Smith's *Normal Love*, being shot in New York at the same time. Trying to describe the experience of working with Jack Smith during this period, underground movie actress Joan Adler finds herself in Criswell's Twilight Time: 'A world of constantly shifting realities, illusions, hallucinations, mysteries, possibilities. Where madness waits for those who falter, beauty for those who are without self-consciousness. Plots appear, shimmer, threaten, evaporate or die. Roles change, shift, take on new meanings, mean them all at once, shift back to which one you decide to live with for now.' Has there ever been a movie title more suited to its times than *Normal Love*?

Orgy of the Dead begins, like *Carnival of Souls,* with a car spinning out of control and crashing. Bob and Shirley have been out for a moonlit drive. He is a writer of successful horror stories in search of inspiration. 'My monsters have done well for me,' Bob blandly remarks before misjudging a curve and overturning the convertible outside the gates of the ancient burial ground where Criswell sits calmly waiting. 'Time seems to

stand still. Not so the ghouls when a night of pleasure is at hand,' the Emperor of the Dead decrees. 'If I am *not* pleased by tonight's entertainments, I shall banish their souls to everlasting damnation!' The young couple are subsequently tied up and forced to watch one topless dance routine after another featuring slave girls, women of the night, female lovers of fire and worshippers of snakes. Every bump and grind has its own damning tale to tell. Trapped in the Twilight Time, Shirley is offered to both the Wolf Man and the Mummy for their pleasure. 'You will not be so fortunate,' Criswell informs a struggling Bob. 'Your existence will cease within moments. No one wishes to see a man dance.'

Meanwhile big beat surf guitars and a scratchy soundtrack announce that a radioactive astronaut is on the loose in Herschell Gordon Lewis's *Monster a Go-Go!* Thrown together in order to fill out a double feature, the movie is a sleepwalking series of non-sequiturs, continuity errors and narrative statements that do not correspond with any visible evidence. 'Do you remember that song?' a woman asks a man in an empty, silent restaurant. 'Would you like to dance?' he asks even though no music is playing. She declines. 'Good,' he says. 'There wasn't much of a movie, no cli-

max or anything,' Lewis will later admit. Starting out in 1961 as *Terror at Halfday*, *Monster a Go-Go!* confronts its audience with Criswell's Twilight Time as the technical fragmentation of commercial cinema. Lewis purchased an unfinished horror flick from director Bill Rebane, added additional scenes and a voiceover, then promoted the result as a 'parody' of the genre under the pseudonym Sheldon S Seymour. The effect is like watching a machine slowly dismantling itself. People, scenes, everything that might loosely be called the film's 'action', disintegrate onscreen. Emotionless performers struggle with uneven sound levels and cheap effects, repeating the fragmented pointless actions of those trapped in the afterlife. In a parked car late at night in the middle of nowhere a teenager kisses a girl, trying to get his hand under her blouse. Angrily she gets out of the car. The radioactive astronaut briefly appears. She screams. The teenager lies dead. Investigating scientists and members of the military immediately walk in from the right of the screen and start examining the body. Throughout the entire sequence a dog can be heard barking repeatedly in the background.

Meanwhile in *Orgy of the Dead* Bob's girlfriend Shirley crosses over into the Twilight Time. She is played by

Pat Barringer, a topless model and dancer who also appears as the 'woman who loves gold above all else' in one of the film's more exotic routines. 'She couldn't do shit,' the Wolf Man later remarks. 'And those tits are plastic, by the way.' Shirley is also Ed Wood's preferred drag name. 'From where I stood beside the camera watching a director with a series of dancers, they looked pretty bad,' he writes of the production, 'but when the film was shown, it turned out to be a classic of beauty and grace.' By the end of her sequence Barringer is completely covered with gold paint in imitation of the latest James Bond feature, *Goldfinger*. 'We've had to use a certain amount of nudity along with realistic violence in our pictures,' Wood says of the bondage and whipping featured in the movie. 'However, we try not to put in nudity just for nudity's sake. If nudity is used for ultraviolence, it has to mean something to the progression of the story.'

The Hollywood studios, he claims, follow the same sleazy logic. 'Torture! Torture! It pleasures me!' Criswell exults.

XIX
Eighth Circle

The
Third Gullet

At Midnight I'll
Take Your Soul

••• ✚ •••

In 1965 Salvador Dali publishes an account of a press conference in which the surrealist painter demonstrates to an 'ecstatic perfume manufacturer' how a photo journalist's used flash cube will supply the packaging theme for a new perfume. And what is this unique new perfume destined to be called? *'Flash! Flash! Flash! everybody calls out Flash!'* The nature of belief starts to alter significantly. 'For no one who wholeheartedly shares in a sensibility can analyze it,' Sontag notes of 'Camp', 'he can only, whatever his intention, exhibit it.' All that remains is the pose as blankly impassive response. Despite its coolly ironic surface display, the New Sentimentality holds within it a rebellious type of frenzy — a swelling of intellectual pride that eats into the soul.

Something between an avant-garde 'happening' and a cocktail party is taking place. Writing for *Harper's Bazaar*, Tom Wolfe describes a society gathering of 'Lower East Side bohemians, boho campies, East Seventies campies, Harlem delivery boys, potheads, pop artists and photographers.' What he detects within this highly select and diffuse crowd, hosted by uptown social thrill-seekers, is the emergence of a 'Pariah Style': a 'new chic' in which the cheap, the offensive and the vulgar have cultural prominence. 'This is 1965 for chrissake,' Wolfe observes. 'There must be some way to have Society do this thing — go *pariah* — utterly, divinely, naturally, baroquely, naturally and baroquely somehow, making itself like a stepped-on roach…with *elan*.' Particularly characteristic of this look, he notes, is bouffant hair 'done San Gabriel Drag Strip-Girl style, *essence* of Pop Art.' Such heightened activity results in a certain kind of fatigue, however. 'Besides,' Marcel Proust declares, 'as all novelty depends upon the prior elimination of the stereotyped attitude to which we have grown accustomed, and which seemed to us to be reality itself, any new form of conversation, like all original painting or music, must always appear complicated and exhausting.' With Trash you are never satisfied.

XIX
Eighth Circle: The Third Gullet

'Young, good looking, crew cut, Ivy League, advertising exec type fruit holds the door back for me,' William Burroughs records in *Naked Lunch*, describing an encounter on the New York subway system at the start of the novel. 'I am evidently his idea of a character. You know the type comes on with bartenders and cab drivers, talking about right hooks and the Dodgers. Calls the counterman at Nedick's by his first name. A real asshole.' The pariah enters the social mainstream just as the advertising industry, together with the white-collar executive and the suburban station-wagon existence it promotes, have become the aspirational norm — for a lot of people, at least. 'I drew closer and laid my dirty junkie fingers on his sharkskin sleeve,' Burroughs continues. Authenticity becomes the highest form of ironic detachment. *Naked Lunch* is charged with violent obscenity in Boston Superior Court.

'THE ACTION BEHIND THE HEADLINES!' screams the poster copy. 'Bike Riding HOODLUMS FLAT-OUT on their MURDER cycles...' In 1965 Russ Meyer joins the Walpurgis Party with *Motorpsycho*: a low-budget movie following antisocial young bikers Slick, Dante and Brahmin in an ill-fated *hejira* across the desert to Las Vegas. Caught in the unforgiving Californian sunlight, these

Scorpios ride laughably small dirt bikes with step-thru frames and listen to tinny beat instrumentals on a plastic-looking transistor radio. They bop distractedly around the wilderness, talking hip, beating on any man they encounter and sexually assaulting attractive young women. Brahmin, like the original Scorpio, is a veteran of a foreign war and is suffering from psychotic flashbacks to his time in Vietnam. This kind of cultural dissonance is still a relatively rare occurrence in American cinema of the period. When Slick accidently kills a man in a roadside fight, Brahmin follows the only logical course of action open to him: he shoots all three dirt bikes and abandons them to the desert sun. The mineral landscape seethes around *Motorpsycho*'s characters in stark black and white: every gesture and comment is brutally enlarged. 'She'll be all right in a week or so,' a local sheriff gruffly remarks from the back of an ambulance, referring to one of the bikers' latest rape victims. 'After all, nothing happened that a woman's not *built* for.' The fact that the sheriff is played by Russ Meyer himself brings a grim self-revelatory edge to the line's delivery.

'How did the Angels grow to be such disliked hell-raisers?' *True Detective* asks, as outlaw bikers make it into

the pages of *Life*. 'The answer is it wasn't easy. They worked overtime at being crafty, cruel and cowardly.' The violently erotic mystery of the Walpurgis Party comes together with the orgiastic brutalities of the men's adventure magazines in the glamourising of the California Hell's Angels. 'The Hell's Angels as they exist today were virtually created by *Time*, *Newsweek* and *The New York Times*,' one journalist remarks. By the height of the mid-1960s the Hell's Angels represent the focusing black hole of American pop culture: a wasted vanishing point at the end of the highway — 'they're the last American heroes we have, man,' declares Ed 'Big Daddy' Roth.

In the relationship between bodies and machines the essential makings of cinema are to be found. To exist on film is to replicate yourself continually across a specified timeline: pop culture depends upon endless repetition and cheap imitation becoming inextricably intertwined with each other. The leering come-on and the arousing putdown are in play here, and both of them cause damage. The mainstream's fascination with Camp replicates what Nietzsche diagnosed in a previous age as 'evidence of weariness, of a desire for diversion at any price, of a tattered memory and

incoherent personal experience.' The cultural fatigue surrounding Camp, however, is provoked by a need for change — although need is never a carefully reasoned position. 'A pussy cat,' Criswell reminds us in *Orgy of the Dead*, 'is born to be whipped.' One men's adventure magazine editor admits that he preferred not to talk about his work 'until the era of camp and put-on when it became a strong social advantage to identify yourself as the managing editor of *Forced Enema*.'

While the roughie establishes itself as the new adult movie genre, the action of Warhol's early talkies inches towards sadism, emotional cruelty and torment. Unseen by the camera in *Screen Test #2*, filmed in 1965, Ronald Tavel mercilessly taunts drag queen Mario Montez, whose eager reactions fill the entire frame. As a potential movie star, proclaims Tavel, she must learn to pronounce certain words with the correct inflection. 'The voice starts drilling her on a word over and over,' according to one of the film's viewers. 'The word was "diarrhea". "Di-ah-rii-aaaa", and her lips form the syllables lovingly and obscenely, her eyes darkened under lowered lids.'

✦✦✦ ✝ ✦✦✦

As one of the Factory's main workers will later point out: 'Andy's sort of beyond sophistication.'

The
Fourth Gullet

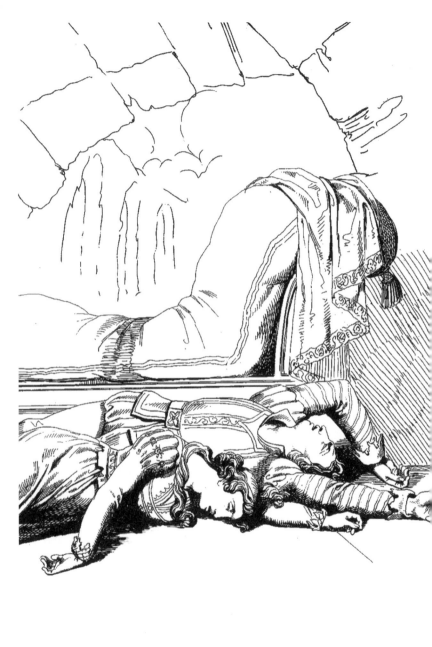

Hotter Than Hell's Angels!
Hot Rods To Hell

··· ✝ ···

Colour newsreel from 1965 shows TV's Tommy Ivo building his own 'AA fuel dragster': the former child actor turned professional racer is seen assembling its tube metal fame in a dingy garage. 'How much comfort does one need for a ride that normally lasts less than eight seconds?' wonders a voice on the soundtrack. A slingshot design raked over a lengthened wheelbase with monster slicks at the back has shifted drag racing into the future at neck-snapping speed. Mounted in the centre of the skeletal fuselage is a powerful engine exposed to the air so it can suck in more oxygen; a supercharger sits on top forcing extra fuel into the cylinders. 'The front end of a fueler is like the tip of an arrow,' the voiceover continues. 'It must be light and right, or there will be no truth in all the rest.'

Drag racers are already ahead of their time before they know it. Over at the massive four-lane Rockford Dragway in Illinois, legendary 'Big Daddy' Don Garlits decides to fix his new Chrysler 462 Hemi 'for keeps' by blowing it up. Frustrated with the sluggish performance this particular engine has been averaging in 'Swamp Rat VIII', his latest slingshot, he increases the spark lead to 40 degrees, assuming this will crack the cylinders. Instead 'Swamp Rat VIII' clocks 214 mph in 7.51 seconds without needing so much as an oil change at the end of it. Stunned, Garlits puts 50 degrees into the Hemi for a second run at 219 mph in 7.31 seconds. It was, he claimed, a shot heard round the world.

The mathematics behind the next generation of dragsters becomes truly fiendish. Then there is the noise: engines cackling like a flame come to life, followed by a sensual ground-pounding roar that moves you to the core of your being. For drivers like 'Connie' Kalitta, Don 'The Snake' Prudhomme, 'Jungle Jim' Liberman, Barbara Hamilton and Paula Murphy, the start of every race is a moment of physical crisis, a state of controlled chaos unleashed upon the world.

The summer crowds flock to see the big machines and to smell their heavy chemical exhalations. According to Von Dutch, 'the nut and bolt are the summation of generations' worth of effort to conquer metal technology, and we should all be aware of their significance.' Nitrous oxide and nitro-methane fumes wreathe the air. Kenneth Anger sees in them the eroticisation of the automobile. He plans to make a film comparing the cultish glittering allure of the hot rod and custom car with that of 'Mae West in her "Diamond Lil" impersonations of the Thirties.' Anger imagines the car customisers and mechanics as shadowy and mysterious 'arch priests' under whose occult guidance 'the Teenager's Dream Car is born (allusion to obstetrics).' A written treatment for *Kustom Kar Kommandos* suggests that it will be a copy of *Scorpio Rising*, which is perhaps why it will never be made. All that exists of the film is three spellbinding minutes of a young boy in tight blue pants and matching T-shirt caressing the engine and chromed interior of his custom car with a white powder puff, while the Paris Sisters croon a spectral version of 'Dream Lover.' The words 'ANGER '65' materialise at the end like an auto show logo, and the enchantment is over.

Ken Hollings: Inferno

A book on Pop Art published in 1966 attributes a custom-ised motorcycle helmet to a 'Von Dutch Holland' adding that 'Holland is a professional painter of custom cars, not an "artist"' — but who precisely is fooling whom here? Glamour is a form of violence — the casting of a cruel spell. 'SUPERWOMEN! BELTED, BUCKLED AND BOOTED!' roars the promotional copy for *Faster, Pussycat! Kill! Kill!,* Russ Meyer's latest release, conjuring up unspoken fantasies of domination and death. Meyer repeats the desert setting of *Motorpsycho*, replacing boys and bikes with girls and hot rods. The 'San Gabriel Drag Strip-Girl style' is back in the form of Tura Satana, Lori Williams and Haji, who also appeared in *Motorpsycho*, playing go-go dancers with a passion for racing fast cars and snapping men's spines. An opening voiceover warns the audience of a 'new breed' of female who lives for just this kind of kick. 'One might be your secretary,' the voice-over asserts, 'your doctor's receptionist or a dancer in a go-go club.' Cue song — cue dance routine.

'Hear "Faster Pussycat" sung by the Bostweeds,' a poster for the film advises, zipping exploitation and pop ever more tightly together. The song itself is an upbeat electric anthem to wild women and untamed

youth that can be heard playing on the jukebox in the dingy bar where Satana, Williams and Haji gyrate in spangled G-strings before a leering all-male audience. 'Diamond Lil' is back. A sudden jump cut to the three dancers roaring down the California highway in sleek, high-speed roadsters throws bodies and machines together in an ecstasy of violence. Hot rods hug female curves — Meyer has completed Anger's projected eroticisation of the automobile. 'The All-American boy — a safety-first Clyde,' Tura Satana sneers at a young male racer they encounter in the desert. She challenges him to a drag race on a dry lakebed, shuts him down then overpowers him in a fight, breaking his neck. The go-go dancers run off with the boy's traumatised girlfriend, abandoning his body and his car to the white desert's glare. In 1966, with *Faster, Pussycat! Kill! Kill!* on general release, the poet O'Hara dies of injuries allegedly sustained when a dune buggy runs over his head while the poet is sleeping on the beach at Fire Island.

The script for *Faster Pussycat!* is often wordy and overwritten, which means that the actors are not actually left with much to say. The plot involves a crippled old man in a wheelchair, who is literally sitting on a stack

of money, and a handsome idiot of a son who flexes his muscles in a tight T-shirt and gets crushed to death against a wall by Tura Satana's snarling custom roadster. The stark and dusty sun-bleached landscape renders every gesture and grimace both mythic and banal at the same time: as if they were in a Sirk melodrama being shot by the same team who are busy filming Andy Warhol's *My Hustler* on Fire Island in the late summer of 1965. Dismissed by *The New York Times* as a 'fetid beach-boy film', *My Hustler* has its own handsome idiot in the form of Paul America, first seen half-naked, playing in the sand with a switchblade, unconcerned by the camera's gaze. Meanwhile the cast makes calculated bets over who will seduce him first. This is very American cinema. 'You don't have to believe it, honey, just act it,' Tura Satana instructs Lori Williams in *Faster, Pussycat! Kill! Kill!*

She could just as easily have been talking to the blond superstar stretched out on the Factory's version of Party Beach.

The Fifth Gullet

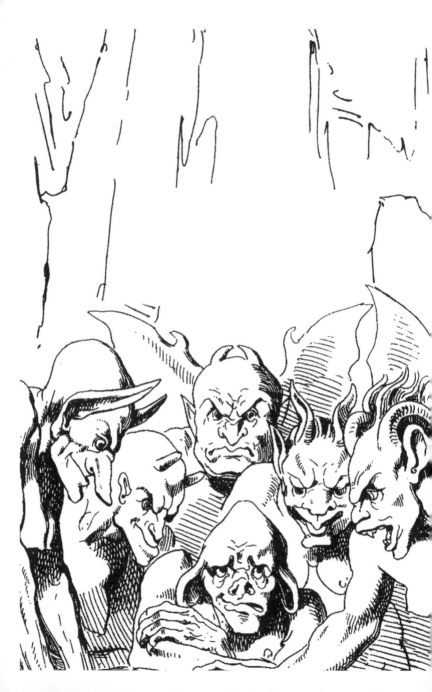

The Revealing Story of Today's Hallucination Generation

••• ✝ •••

In January 1966 Andy Warhol and Roy Lichtenstein attend the New York premiere party for *Batman*, ABC's new television series based on the DC comic-book character. The show's cast and crew remain on the West Coast where filming continues at the Fox studio in Culver City. 'Pop art and the cult of camp have turned Superman and Batman into members of the intellectual community,' *Life* magazine breathlessly confides, 'and what the kids used to devour in comic books has become a staple in avant-garde art.' *Life* interprets this cultural condition in broadly pathological terms, presenting it as some gleeful form of mass insanity: 'MAD NEW WORLD of Batman, Superman and the Marquis de Sade,' its cover proclaims. Meanwhile *Batman* star Adam West observes the number

of businesses 'running to DC or Fox with pens drawn, wanting to do gum cards or soundtrack albums or model kits.'

The business of Camp is symptomatic of a certain cleaning up of popular culture — not so much failed seriousness as a disguised one. 'Dirt is the by-product of a systematic ordering and classification of matter, in so far as ordering involves rejecting inappropriate elements,' remarks Mary Douglas in *Purity and Danger*, her classic study on the cultural anthropology of pro-hibition, first published in 1966. 'This idea of dirt takes us straight into the field of symbolism and promises a link-up with more obviously symbolic systems of purity.' The Comics Code Authority has been busily turning superheroes into playthings by making it impossible for them to be anything else. With vam-pires explicitly banned from the pages of comic books, Batman becomes a dayglo Dracula haunting a moral universe outlined in neon colours. 'Support your po-lice: that's our message,' declares his teenage sidekick Robin, pounding his fist. Popularity is the progressive thinning out of resistance. *Purity and Danger* could easily double as an alternate title for the entire *Batman* TV series.

'Dirt offends against order,' Douglas observes. 'Eliminating it is not a negative movement, but a positive effort to organise the environment.' Intensely expressive of what *The New York Times* calls the 'avant-camp', Batman's eyes gleam from beneath stylised eyebrows pinstriped in white on his black mask, a corresponding motif outlining the bridge of his nose. Isolated and alone, Batman's costumed gaze transforms identity into an anonymous enigma: a playful monster of human virtue. By masking themselves in their own reality, superhero and super-villain erase all that went before them, cancelling out the individual self in favour of a purely symbolic presence. Nothing offends order like a secret identity.

To evade responsibility for their actions, Batman and his adversaries inhabit a customised empire of signs and motifs. Costumes, weapons and vocabulary assume the likeness of their users, whether it's The Joker, The Riddler, Catwoman or The Penguin. A visual strain of paranoid schizophrenia asserts itself. The bending of reality to a claimed identity is the prevailing law of this universe: reflected in the off-kilter camerawork used in scenes involving super-villains, as if their very presence distorts perception.

The pop-culture universe buckles under the weight of assumed identities. Kustom King George Barris creates a $30,000 Batmobile for the television series out of a 1955 Lincoln Futura, a Ford prototype 'car of tomorrow.' 'Atomic batteries to power! Turbines to speed!' Robin ritually announces as the engines fire up. Unlike hot rods and dragsters, however, custom cars are built for looks not speed; the Batmobile's sleek dark line barely disguises the fact that it handles poorly and breaks down several times during filming. Under-cranked footage of the Batmobile exiting the Batcave — actually an excavation at LA's Bronson Canyon used in countless B movies — adds to the illusion of power and dynamism. It's the same old trick used in the Flash Gordon and Captain America movie serials to speed up the action.

To play with masks and costumes is to produce monsters. Everyone brazenly hides from each other and from themselves. Names are changed to protect the guilty. Just ask Scorpio, Tura Satana, Mario Montez or Paul America. Ron Haydock, AKA 'Vin Saxon', AKA rock idol Lonnie Lord is seen walking down an LA street carrying a guitar. 'Lonnie lives in Hollywood, the entertainment capital of the world,' the viewer is informed. 'It's

his town and everywhere he goes, he carries his guitar with him because he never knows when he'll be called upon to sing. Lonnie will sing a song anytime anywhere. Lonnie,' the voiceover adds for emphasis, 'likes to sing.' Released in 1966, Ray Dennis Steckler's *Rat Pfink a Boo Boo* is less of a movie than a protracted series of shifting identities and unexpected mood swings. In scenes lit only by neon signs and a waxing moon it starts with a lonely streetwalker being terrorised by a giggling bunch of sex fiends known as 'The Chain Gang.' Soon they turn their attention to Lonnie's girlfriend Cee Bee Beaumont, calling her late at night and following her to the local supermarket. 'I got a word for you because it's what you is,' Lonnie sings cheerily at a wild pool party unaware of what is going on. *'You is a rat pfink! You is a rat pfink!'* Everyone in this movie seems to wear tight pants.

When the Chain Gang kidnaps Cee Bee, Lonnie has no choice but to step into a closet and become masked crime fighter Rat Pfink. Joined by his sidekick Boo Boo in his Ratcycle, he rescues Cee Bee by tricking her abductors into accepting a suitcase stuffed with monster magazines and comic books instead of the ransom money. What began as a psychosexual shocker called *The Depraved*, scripted by Vin Saxon, ends with Rat

Pfink, Boo Boo and Cee Bee fighting a gorilla, taking part in a local parade and partying at the beach. Vin sings all his own songs.

If camp is failed seriousness, what then is failed comedy? Jerry Warren's *The Wild World of Batwoman* openly flirts with copyright infringement, pitting its heroine against the masked villain 'Rat Fink.' The proliferation of aliases, stage names and assumed identities becomes a hard presence in a universe that is itself completely fake. They represent a flamboyant way for the pariah to stay in the shadows. California Hell's Angels go by Zorro, Magoo, Mother Miles, Mouldy Marvin, Terry the Tramp and Junkie George. William Burroughs populates his *Naked Lunch* with characters like the Rube, the Vigilante and the Shoe Store Kid. Factory regulars Ondine, Billy Name, Binghamton Birdie and The Duchess refer to Andy Warhol as 'Drella' — a contraction of 'Cinderella' and 'Dracula'. They are also known as 'The Mole People' — amphetamine users who dress in black, avoid daylight and wear sunglasses to hide the condition of their pupils from close public scrutiny. They owe their name in part to the 1956 Universal Pictures release about an underground race of ancient Sumerians who live off mushrooms and worship the goddess Ishtar.

··· ✠ ···

While teenage girls do the hippy hippy shake armed
with rifles and handguns, footage from *The Mole People*
is cut into *The Wild World of Batwoman*'s swinging
incoherence.

The Fifth Gullet Continued

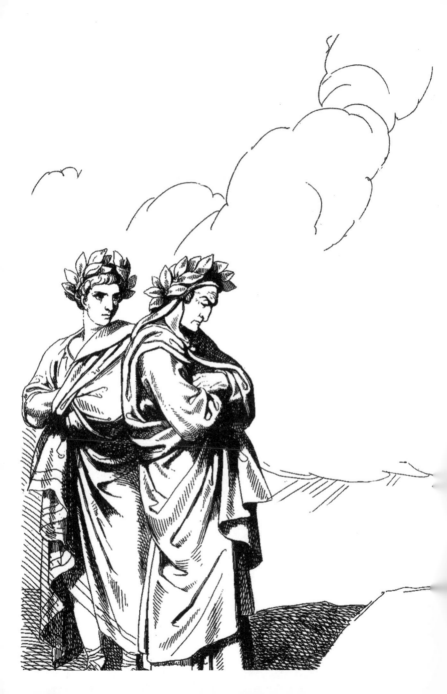

Out for kicks...in for trouble! Born Losers

··· ✟ ···

Superheroes always need a second identity, if only to conceal their invulnerability: forever damned by an unacknowledged passion for destruction that divides them against themselves. 'Everything that can happen to a man in the way of disaster should be catalogued according to the active principles involved in the universe of his particular culture,' observes Mary Douglas. Back in 1924 Fritz Lang's *Die Nibelungen*, a two-part cinematic adaptation of the Siegfried myth, becomes the favourite viewing of Adolf Hitler and Joseph Goebbels. Siegfried is shown slaying a life-size mechanical dragon and bathing naked in a gushing torrent of its blood. Sex and death will always inform a hero's every move; Siegfried's bare skin is rendered invulnerable — but a single leaf

innocently sticking to his shoulder blade is enough
to leave him exposed in that one spot even as the
rest of him grows impervious to all disaster. Dirt, as
Mary Douglas reminds us, 'is matter out of place.'
The spear that will kill Siegfried has yet to be thrown
but has already found its target.

Variations on the same primal scene play out across
Hell. Repeating individual versions of the same sin,
the damned lack all pretence at originality. We have
seen this before and will be forced to see it again.
'What's with that Iron Cross? You one of those dumb
Angels?' Dick Miller demands of Peter Fonda, play-
ing a prettier version of Scorpio in Roger Corman's
The Wild Angels. One year earlier Fonda had taken
LSD with the Beatles and the Byrds at a Beverly Hills
party, telling them about the time he shot himself
in the stomach as a child and showing them the
bullet wound. The part of the body most exposed to
tragedy is also its weakest. 'I know what it's like to
be dead,' a hallucinating Fonda keeps repeating until
John Lennon demands that he be thrown out. Mus-
cles and leather and grease-stained denim form a
protective outer skin: an amulet of flesh. But a cross
still marks the spot.

··· ✠ ···

An award for bravery first introduced in 1813 by King Frederick Wilhelm III of Prussia, Hitler established the Iron Cross as a German military decoration in 1939, adding a swastika to its centre. By 1966 the 'Surfers Cross' is a visible part of teenage culture from coast to coast. 'Dug out of attics and curio shops and freshly minted by the thousands,' *Time* magazine reports, 'the German Iron Cross has become the newest surfer's emblem and high school fad.' Ed Roth is supplying the kids with pendants and decals based on the Nazi medal, telling *Surfer* magazine that 'the real reason it's become so popular with surfers is that basically the Iron Cross is a good design.' Roth also offers his young customers replicas of the Wehrmacht steel helmet in chromed plastic. 'You know,' Roth informs *Time* magazine, 'that Hitler did a helluva public relations job for me.' Every outlaw and adolescent has a Siegfried hidden somewhere deep inside them: their shared culture hides a flawed invulnerability, however tightly they might attach themselves to the protective power of amulets. In its Bulk Vending News section, the June 18 issue of *Billboard* notes that to teenagers the Iron Cross 'meant some vague form of protest, rebellion or individuality'. Easily overlooked in that remark is the trashy pride to be found in publicly branding oneself an outsider, a vilified loser. 'It really upsets your parents,' a fifteen-year-old surfer from Palmdale reveals

to *Time*. 'That's why everybody buys them.' The parents' generation sees things in a slightly different light. 'We used to kill guys who wore that kind of garbage,' Dick Miller snarls at Peter Fonda. The amulet cannot protect the wearer from the weakness it covers.

With a swastika worked into its opening title design, *The Wild Angels* offers the thrill of the immediate, boldly listing as extras in its credits 'members of HELLS ANGELS, Venice, California.' Authenticity in this particular case is another form of blankness. Characters only exist in Corman films as a collection of projected spaces from which specific lines can be delivered. Peter Fonda is leader of a California bike gang. Dick Miller, a regular face in Corman productions playing bohemians, blue-collar rebels and working stiffs since the 1950s, brings a wiry, craggy charm to his portrayal of an oil field rigger — but in the end he always plays Dick Miller just as Peter Fonda always plays Peter Fonda. 'His actors always appear vacant and transparent, more like robots than people,' the artist Robert Smithson remarks of a typical Roger Corman production, '—they simply move through a series of settings and places and define where they are by the artifice that surrounds them.'

The accelerated violence of Trash cinema represents a parody of lust, acting out a revolt against authority and convention. An aggressive combination of brutality, sentiment and innocence that tends to be invoked whenever sons rise up against their fathers, it is a symbolic assertion of male banality. With very little plot to get in the way of the action, California biker movies are made up of long, seemingly endless highway scenes and long, seemingly endless party scenes intercut with fights, snatches of dialogue and the occasional throwaway gesture. *The Wild Angels* is part of a daisy chain of countercultural Trash featuring hippies, drugs and outlaw motorcycle gangs in one combination or another. The threads connecting these movies can be found in their virtually interchangeable casts. Each duplicates a similar combination of faces. This being Hollywood, the stars are either Tinsel Town hucksters like Bruce Dern, Dennis Hopper and Jack Nicholson, or the offspring of the famous trying to slip out from under Daddy's shadow, such as Peter Fonda, Nancy Sinatra and Susan Strasberg. This is the disorientation of mass production: the sublime horror of repeatedly encountering the nearly identical. 'The menacing fictions of the terrain engulf the creatures that pass as actors,' Smithson concludes. '"Things" in a Corman movie seem to negate the very condition they are presented in. A parodic pattern is estab-

lished by the conventionalized structure or plot-line. The actors as "characters" are not developed but buried under countless disguises.'

When it comes to Trash cinema, the deepest disguise must be taken literally. The stark blending of mannerism and brutality in Fritz Lang's *Die Nibelungen* carefully arranges rampaging Huns and ironclad warriors thirsting for blood into a neat aesthetic order that exemplifies cinematic excess. But trying to separate actors from their actions, and casts from their consequences, proves too difficult in the end. The economic and physical conditions of exploitation cinema dictate that Hell's Angels should be played by Hell's Angels. Founder of the Oakland Angels Ralph 'Sonny' Barger is quick to make the connection. 'It was something to do,' he says of their involvement in low-budget movies, 'something we could do without thinking too much.'

The Hell's Angels of Venice, California threaten to kill Roger Corman over his depiction of them in *The Wild Angels*, eventually agreeing to a cash settlement.

The
Sixth Gullet

This Night I'll
Possess Your Corpse

••• ✚ •••

'It's shocking,' the poster copy warns. 'A cult of weird and horrible people who gather beautiful women only to deface them with a burning hand!' Culture is the harbinger of collapse and foreshadows the gradual laying waste of humanity. In other words, it transforms itself into Trash — except we no longer recognise it as such. This failure does not constitute a final state of affairs but a continual process: one based entirely upon repetition, which is a modern form of compulsion. *'Manos': The Hands of Fate* tells yet another tale of the Twilight Time — of what happens when inappropriate elements are organised into an environment of their own.

A teenage couple are necking in an open-top roadster, parked on some blasted stretch of desert wasteland. *'Baby, do a thing with me — it feels so good'* runs the jangly pop song accompanying their make-out session. The teen couple nip from an unmarked bottle of booze. A tired-looking sheriff pulls up in his patrol car. 'How many times do we have to chase you kids?' he asks wearily. 'Holy cow, man — you'd think we were doing something wrong,' protests the teenage male. 'Well whatever it is you're not doing,' the sheriff replies, 'go *not* do it somewhere else.'

The only lasting mirages produced by a desert are the cheap movies made there. They seem real and authentic, but the sight of them is deceptive, especially when the script kicks in. Filmed in El Paso and premiered at the town's local cinema, *'Manos': The Hands of Fate* briefly haunts the drive-ins of West Texas and New Mexico before disappearing until century's end. Written, produced and directed by Hal Warren, it exists only to prove that he could make a horror flick and to win a bet. Working with an amateur cast and crew and using equipment that barely conforms to professional standards, everything about his film seems slightly out of focus — as if taking place in some partially

glimpsed parallel universe. 'He was a nice enough guy... didn't realise that he was just fuckin' nuts, just totally fuckin' nuts, just wacko out — because he was,' comments the actor who played the teenage male.

Horror movies, especially the cheaper ones, show reality in a state of crisis. Everybody wants to play a monster, even if they secretly won't admit it. The movie set provides the cultural pariah with a refuge from the straight world. Self-contained and exclusive, where only the most elect of the abject can claim a space, it is a conduit to the narrowest and most elevated condition allowed in modern society: fame. The technology of lenses, cameras and celluloid offers a selectively democratic access to celebrity for those who crave it. Lost in a desert, a typical American family falls victim to the cult of Manos. Hal Warren himself plays the father. 'She'll understand, she's my baby, she'll understand,' he mumbles as his young daughter wanders unnoticed out of the room. Outside a large black dog prowls a night filled with moths attracted by the camera lights. 'She's my baby,' he repeats, filmed from another angle, 'she'll understand.' This is cinema as pornography, its organs exposed. The family finds itself trapped by the Master, his servant Torgo and many 'wives.' The only ac-

tion on display in *'Manos': The Hands of Fate* is the technology of film slowly taking itself apart. The American family seems weirder and more horrible than the cult that terrorises them: their life together lame and pointless. 'Killing doesn't help anymore. You're all finished!' someone says in the movie — it doesn't really matter who. There is still that large black dog; and the hip teen couple reappear, making out with the same passionless intensity in a series of cutaways, but that's about everything. The Master has a zipper up the back of his magisterial robes — and the soundtrack is an unbearable collage of dubbed dialogue, intricate modern jazz arrangements and looped dog howls from an old sound effects album. 'He's dead,' Hal Warren says of the family mutt after it disappears into the desert. 'Pepe's been killed.'

Drugs and technology form strange new communities. Speed and acid make for a bad mix. Technique transforms style into the parody of style; and such displays cannot be saved either by love or irony — only the democratic extravagance of fame is left. The craving for overwhelming experience requires an overwhelming technology. 'It was drugs,' Warhol says of the spontaneous unscripted performances captured in his

films during the late 1960s. 'On drugs everything is like a movie. Nothing hurts and you're not the way you used to be or would have been.' Caught by the lights and the camera, chemically illuminated from within, Warhol's performers are already projected into the future. Drugs allow Warhol's superstars to anticipate themselves; every word and gesture has the potential significance of what 'would have been.' A sketch made by Andy Warhol in June 1966 shows two rectangular movie screens side by side with the words 'LSD movie' written above them.

A programme note accompanying a screening of Kenneth Anger's 'Magick Lantern Cycle' suggests that 'psychedelic researchers desirous to Turn On for Pleasure Dome should absorb their sugar cubes at this point,' referring to a brief intermission before *Scorpio Rising* is screened. Part elaborate costume party and part occult rite, Anger's *Inauguration of the Pleasure Dome* has enjoyed a revival of interest in the Age of Aquarius. Anger has arranged for a richly enhanced and over-laid 'Sacred Mushroom Edition' of the film, subtitled *Lord Shiva's Dream*, to be playing just as the LSD hits the audience. This version of the film, the programme note stipulates, 'should, under ideal circumstances, be

experienced in the Holy Trance called High.' That same year possession of LSD is made a misdemeanour offence in the state of California.

9.4.07 — San Francisco: memories of an afternoon in Golden Gate Park — young guys with dogs trying to sell drugs, as if it were a tradition expected by tourists and visitors — 'Purple Purple' muttered under their breath to anyone passing. Really bad street musicians along Haight — I mean, really bad — 'Hot Sex Without Crystal? Hell Yes!' — public health ad in Castro.

'Don't forget the silly way we met,' a woman croons at the end of 'Manos': The Hands of Fate. Machines are intensifiers of human agency, and the cinematic apparatus is the perfect expression of this relationship: the unedited cranking out of mechanical time measured precisely at 24 frames per second first through the camera and then the projector obliges the actors to focus ahead of themselves, on the nervous edge of what comes next. 'Warhol is adept at using non-actors whose lack of theatrical skill makes the realism of their being

XXIII
Eighth Circle: The Sixth Gullet

wholly convincing,' remarks Archer Winsten in the *New York Post* — but this is about cinema, not theatre.

Growing up with Hollywood stars as his playthings, Warhol still regards the movie camera as the machine of the future: which is to say *his* future.

The Seventh Gullet

Thunder Alley — Their God is Speed...Their Pleasure an Anytime Girl!

••• ✝ •••

Trash transcends itself through the questions it raises. 'In remembering (or hearing once again) the rhetoric praising psychic and social disorientation, the flattery of madness and loss of self in which the 1960's specialized,' one critic writes of Andy Warhol's *Chelsea Girls*, 'one should also remember that the unbearable has, as its prime characteristic, being unbearable — and no fooling.' Presented as two films projected side by side, Andy Warhol's *Chelsea Girls* is the pornography of bodies trapped in time — or, to put it more precisely, decomposing over time. Only attitudes harden here; bodies tauten with anger or flop about, loose limbed and stoned. Mario Montez is reduced to tears by two boys he discovers in bed with each other — they insult him so badly that Montez leaves the set and refuses

to return, even when Warhol begs him to finish the scene. Everything becomes more fluid when recorded in mechanical time. Ed Hood, one of the stars of *My Hustler*, jokes about 'the Kennedy Menstruation', while Eric Emerson licks his own sweat off his hand, talking about how great it tastes, before undressing in front of the camera. 'With us,' Mary Douglas comments in her own study of the unbearable, *Purity and Danger*, 'pollution is a matter of aesthetics, hygiene or etiquette, which only becomes grave in so far as it may create social embarrassment. The sanctions are social sanctions, contempt, ostracism, gossip, perhaps even police action.' A breakout success in New York in the autumn of 1966, attracting both mainstream attention and national distribution, *Chelsea Girls* is too studied and detached to be truly unbearable. At its simplest, acting has become a method for finding the right place to put dirt.

'Until then,' Warhol observes, 'the general attitude toward what we did was that it was "artistic" or "camp" or "a put-on" or just plain "boring." But after *Chelsea Girls*, words like *degenerate* and *disturbing* and *homosexual* and *druggy* and *nude* and *real* started being applied to us regularly.' Made in the summer of 1966,

XXIV
Eighth Circle: The Seventh Gullet

Chelsea Girls is Warhol's LSD film shot on drug time: extended sequences projected simultaneously: one side silent, the other supplying the soundtrack for both. Unscripted and only loosely edited or directed, the movie presents its audiences with a series of lengthy digressions to divert us as we descend further into the Hell of the Deceivers, offering us a new form of glamour. Thanks to the naked power of exploitation cinema, the performers in *Chelsea Girls* appear on screen in deep disguise as themselves. Lost in her role, The Duchess shoots up on camera and uses the Chelsea Hotel's main switchboard to call up actual friends, offering to sell them drugs and quickly drawing the actual attention of the actual police.

At this point in Factory history there is no creature more fabulous or more frightening than Ondine: male prostitute, drug fiend, poet and actor — a fanatical opera fan, Ondine is Norma, Tosca and Violetta all wrapped up into one magnificently trashy package. His amphetamine-fuelled routines, both on and off camera, occur at the point where tragedy and crudity meet. He suddenly flies into a rage in *Chelsea Girls*, throwing Coca-Cola into a woman's face and then slapping her. 'I hit you with my unfisted hand, you

dumb bitch,' he yells as the girl runs off. 'How dare you come onto a set and tell me that I'm a phoney on *my* set...goddamn it...I want to smash her face in, that cunt.' Ondine storms out of shot, says he cannot go on. Warhol, by his own admission, gets upset and has to leave the room, but the camera keeps on running. Critical accounts of *Chelsea Girls* tend to emphasise the reason for Ondine's outburst rather than its effect: Rona Page, the woman he attacks, had called him 'a phoney' on camera. She is at the Factory running an errand on behalf of Jonas Mekas, director of New York's Cinemateque, and has been pushed onto the set with Pope Ondine.

'Ondine was probably the only one who was gorgeous,' co-star Mary Woronov recalls, 'but he was so fierce you never paid attention to how good-looking he was.' She overhears Andy Warhol discussing Pope Ondine's rage with members of the Factory inner circle. 'Apparently he had decked a girl called Rona and they were laughing about it because the audience reaction had been cheers,' she writes. Andy thought it was their best film yet — it was so beautiful. 'Rona was being a cunt,' according to Warhol's assistant Gerard Malanga. 'Yeah but how did he know that we all wanted to hate

Rona?' countered Warhol's other assistant Paul Morrissey. 'How did he know all the audiences sitting in the dark were waiting to hate Rona?' Ondine, according to Woronov, 'carried chaos around with him.' Violence is the figure and chaos the ground from which it emerges. It is all a matter of perception: another form of cinema. 'He should have hit her again,' Malanga replies.

Explanations are always circumstantial — aesthetic judgement is all about looking the other way. 'Raw and crude was the way I liked our movies to look,' Warhol claims. As if to distance himself from any awareness of her presence in *Chelsea Girls*, Warhol misidentifies Rona Page in his memoirs as 'Pepper', confusing her with another performer in the same movie: Angelina 'Pepper' Davis. Rona Page, like a lot of women in exploitation cinema, happens to find herself in the wrong place at the wrong time. By her sudden introduction onto Ondine's set, the ironic detachment, the studied pose celebrated by the New Sentimentality, is utterly confounded. 'You motherfucker! *I'm* a phoney?' Ondine yells after slapping Rona in the face. 'Well, so are you!' Distance contracts — and what the camera reveals is not only raw and crude but also very, very ugly. 'It was the most horrible movie ever made,' Ondine will say of

Chelsea Girls. Compared to Russ Meyer's carefully choreographed sexual violence, it stands alone as the real thing. The calmly cinematic registration of Ondine's assault on Rona Page is the ultimate 'roughie'.

Rage is rage; and its victims understand it as such. Anything that falls within the reach of aesthetic judgement ceases to exist except within those terms, which means that it has been rendered bearable. Consequently the issue is not so much Ondine's violence against Rona Page as its critical interpretation. Art history, after all, has long since professed itself incapable of shock — its responses have been informed to the point of numbness. In Warhol's *Chelsea Girls*, Sontag's 'Notes on "Camp"' have been overwritten and obscured by the motion of body parts: sprawling pale and unfocussed, shooting up methedrine, lighting cigarettes, stuttering, belching, complaining and arguing, overloading the movie's tinny soundtrack.

Ondine's onscreen rage in *Chelsea Girls* is a miserable, abject thing when confronted directly — in the end it's just another man beating up a woman.

The
Seventh Gullet
Continued

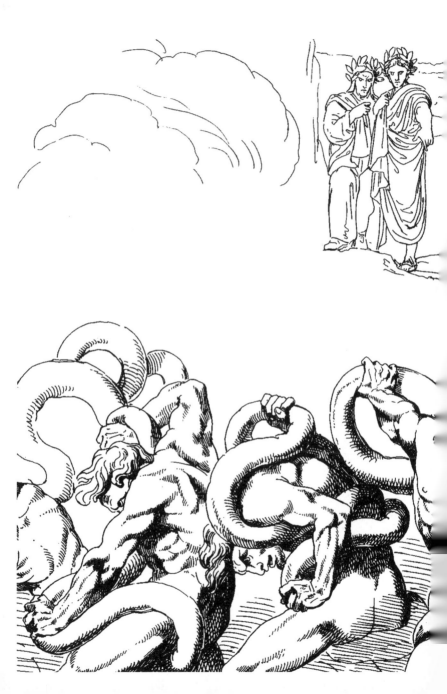

In the Valley
of the Dolls

'Die consciously,' a soft voice advises the listener as
a bell chimes, accompanied by the sound of turning
pages. *The Psychedelic Experience* is a record album
based upon a book of the same name. Timothy Leary,
in association with Ralph Metzner and Richard Alpert,
has written a user's guide to the LSD trip based on a
reading of *The Tibetan Book of the Dead*. One side is
'Going Out'. The other is 'Coming Back'. There is also a
stage show involving music, coloured lights and pro-
jected slides. Death, illusion and enlightenment are
all available at your corner record store. As William
Burroughs drily remarks as the 1960s gradually pre-
pare to unspool their final reel: 'any number can play'.

The emergence of the pop group into mass con-
sciousness at this time brings with it a disposable

form of society. Assuming the broad public image of the street gang, the group's members make a show of subsuming their individual identities within an overriding collective one. The group's name constitutes in turn a form of alias: an extension of the gang's pariah status. At one point Andy Warhol is part of The Druds, an 'artists' rock group' featuring Walter De Maria on drums, Larry Poons on guitar and La Monte Young on saxophone — Jasper Johns is responsible for the lyrics. 'We rehearsed three or four times,' lead singer Patty Oldenburg recalls, 'and then it just fell apart.' Warhol eventually gets his own rock group in the form of the Velvet Underground: a small clutch of Mole People who take their name from an 'adult' paperback picked up off the street, offering salacious descriptions of sadism and wife-swapping in the suburbs.

'Fortunately much of their guitar twanging and nasal dripping is confined to cheap joints called "coffee houses"' Ed Wood writes of the teenagers crowding onto LA's Sunset Strip at this time. 'Each Friday and Saturday night they converge with the police, who make their quota of arrests for all types of disturbances.' By 1966 Sunset Strip has lost all of its Hollywood glamour and is primarily associated with sleazy nightclubs,

rock music and kids cruising in cars, picking each other up and heading for the latest scene. 'As long as drums pound and guitars wail, sleep becomes a thing of the past and everybody makes it together,' a newsreel sternly comments on the 'now generation' hanging around the cellars, strip joints and topless bars. 'Where once the great nightclubs abounded,' Ed Wood records, 'there are only small bistros where the "in" set gathers, where it's difficult to tell the girls from the boys between the beatniks and the long-hairs.' The big movie stars once seen here are now a thing of the past. Towering some thirty feet over them on the Strip, a gigantic sculpture of cartoon legends Rocky and Bullwinkle, striking a burlesque pose, rotates slowly. Lowered into place in 1961, it is the Strip's newest landmark and its cutest monster. Kids cluster together on the sidewalk beneath it, hanging out within its illuminated shadow. 'Sunset Strip is a big nothing,' Ed Wood complains, while Nirvana snaps its gum and blows another pink neon bubble in the Los Angeles night air.

Bubble gum nothingness spills over into teenage rioting one tense night in November 1966 when the authorities try to enforce a curfew on the area. Complaints from local residents force Los Angeles County

to resurrect an old law banning anyone under eighteen from being out on Sunset Strip after 10.00 pm. A crowd of mostly clean-cut teenagers, in the latest surfing and hot rod fashions, windcheaters, T-shirts and jeans, meets to protest this infringement of their civil liberties. They gather outside Pandora's Box: a distinctive youth hangout in the middle of the Strip painted purple and gold and threatened with closure. The trouble starts when a carload of Marines gets into a fistfight with the driver of another vehicle. The police and sheriffs' deputies close off part of the Strip as rioting spreads. Newsreel cameras capture the action. 'Attention! Attention!' an officer shouts through a megaphone from behind a line of cops in riot gear. 'It is now past 10.00 pm! The curfew law is now in effect. Anyone remaining in the area under the age of eighteen years old will be arrested.' Teenage rioters attack a city bus, one youth trying unsuccessfully to set the fuel tank alight. Others hurl rocks and bottles, smashing storefront windows and shattering car windshields. *The LA Times* reports that 75% of all underage arrests that occur during the riots are of children sixteen years old or younger.

Local unrest continues through to December with several clubs and coffee houses being shut down.

Eighth Circle: The Seventh Gullet Continued

Sensationalist movies such as *Mondo Teeno*, also known as *The Teenage Rebellion*, connect civil unrest and violence to rock music, fast cars and hedonistic attitudes towards sex and drugs. *Riot on Sunset Strip*, a cheap cash-in rushed out by AIP, makes heavy play of the teen lifestyle: the customised hot rods, the uptight scenes in basement clubs and the trippy teen fashions. 'Look at you two,' a West Hollywood matron complains, leading her garishly dressed daughters out of a police precinct following their arrest. 'Compared to you, Dracula looked like a fairy princess. Where did you get those ridiculous clothes?' Meanwhile a police chief's daughter is slipped some LSD in her glass of Coke at a party; she takes off her shoes under its influence, striking jazz poses and doing 'way out' choreography — then she is raped by a bunch of clean-cut young mods.

The West Hollywood mother is right about one thing: Universal's Vampire Count no longer thrills them the way he used to. After *Orgy of the Dead* Ed Wood turns to writing 'adult paperbacks' to earn a living. Knocked out quickly and cheaply, these publications adhere to their own self-regulating code in order to remain just within the law. 'Sex scenes had to result from rela- tionships — couldn't be promiscuous or they would

be considered pornography,' one author reveals. 'The books had to have a moral. Good had to shine through in the end. They couldn't even *smell* dirty.' No stranger to Sunset Strip, Ed Wood incorporates scenes of rioting teenagers into the climax to his 1967 opus, *Death of a Transvestite*. With Pandora's Box closing that same year, Wood's sensationalist description of the riot offers an insight not into what has just taken place but what is about to happen: 'Every block of the area found itself experiencing the same destructive forces. Headlights smashed quickly, in violent succession to any with a heavy object in their hand. Nothing was safe or sacred to the mob of maniacs...the call was out. "Kill the fuzz! You want freedom? Kill the fuzz! Kill every last one of them!"'

On 21 March 1967 Charles Milles Manson is paroled from McNeil Island prison after serving seven years for violating the 1910 White-Slave Traffic Act and forging checks.

The Eighth Gullet

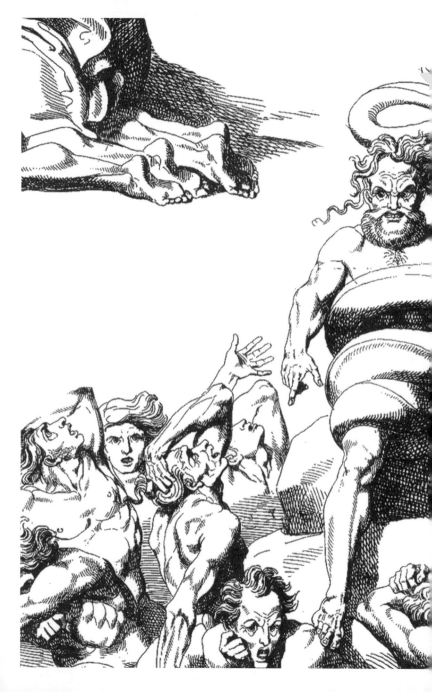

Journey to the Centre of Time

··· ✠ ···

All true heroes are living, breathing disasters. Flash Gordon saves the Earth by conquering the Universe. 'There you go, Astro Boy, on your flight into space,' a child's chorus bawls over the *Astro Boy* opening credits, stressing the Japanese robot hero's association with speed and motion. The connection between boys and machines is taken even further with the 1967 animated version of Tatsuo Yoshida's *Speed Racer*. 'Here he comes, here comes Speed Racer,' announces the theme song. Both cartoons reverberate with the sounds of powerful engines, loud voices and twisting metal. Neither can keep still for a second. Peter Fernandez, who scripts the English-language version of *Speed Racer*, claims also to have worked on *Astro Boy*. The *Speed Racer* soundtrack is heavy with the roar of hot rods and dragsters. Speed's own car, the Mach 5, has more customised lines and special features than the Batmobile: explosions, crashes, smoke

and flames are a feature of every race. In an effort to match open mouths with speech, much of the dubbed American dialogue takes the form of wordless cries and exclamations. As the Mach 5 spins out of control once more, Speed and his girlfriend Trixie moan and sigh together as if they were having sex on its front seat.

'Pornography is one of the branches of literature — science fiction is another — aiming at psychic dislocation,' Susan Sontag observes in her 1967 essay, 'The Pornographic Imagination.' Even as it focuses upon literature, this insight suits the movies of the moment. The 'psychic dislocation' identified with pornography and science fiction is also a kind of revelation. Pornography is not a form but a dimension: an undisclosed space within a culture. This is why Sontag can note how 'pornography and science fiction resemble each other in several interesting ways.' Pornography is the parody of lust in an arid world; and parody is an unspoken form of communication requiring shared knowledge. In other words, it is a text hidden within a text — just as Trash is one state of matter hidden within another. Any attempt at a definition of Trash requires an acknowledgement that the subject must exist outside the discourse that defines it in the same

way that examples of pornography are excluded from any debate they might provoke. The pornographic self-incrimination of Trash requires that things become blurred over, shadowed or blanked out.

Trash Aesthetics mark a collision of materials with meaning. 'A parody of pornography, so far as it has any real competence, always remains pornography,' Sontag observes. A parody of lust trades in dirt as a mood or a set of referents: everything is diffused or deflected, both conditions being forms of prohibition. If it is impossible to parody pornography, as Sontag suggests, is it possible to parody the act of looking at pornography? Can we parody a mechanical process and still take it seriously — and if we can, would that parody take the form of violence? Locked in their noisy embrace with sex and death, Trixie and Speed just keep on crashing in the same car.

Scenes of nightlife on Sunset Strip flicker and flash in Roger Corman's latest low-budget 'head movie', *The Trip*, as Peter Fonda, high on LSD, gapes at the brash glittering world around him. The action is fed

off newspaper headlines and sensationalist magazine articles. 'TODAY THE EXTENSIVE USE IN BLACK MARKET PRODUCTION OF THIS AND OTHER SUCH "MIND-BENDING" CHEMICALS IS OF GREAT CONCERN TO MEDICAL AND CIVIL AUTHORITIES,' a rolling title announces in urgently un-grammatical capitals before asserting that 'THIS PIC-TURE REPRESENTS A SHOCKING COMMENTARY ON A PREV-ALENT TREND OF OUR TIME AND ONE THAT MUST BE OF GREAT CONCERN TO ALL.' Exploitation is the permissive face of repression. The drug's very illegality is what makes the movie possible. Meanwhile the theatrical trailer for *The Trip* promises everything and forbids nothing. 'It will blow your mind,' is its final come-on, the lure of this particular deal being that it also serves as a warning. Protection is another form of prohibi-tion. This, after all, is Los Angeles. Blown minds are part of the landscape. As Peter Fonda continues to wig out on Sunset Strip, illuminated signs, police no-tices and cruising automobiles form a jagged mosaic of effects: a prismatic lens makes the fragmented images dance and collide on the screen. *The Trip* is Hollywood commercialism pretending to go 'un-derground.' Flash Gordon is riding out into space once again. Peter Fonda looks up — the prismatic lens catches the Rocky and Bullwinkle statue and sends it spinning across the inky black sky over West Hollywood. Roger Corman is rumoured to have tried

LSD while preparing to direct *The Trip* — a 'Lovely Sort of Death', the poster promises. Rocky and Bullwinkle smile down upon the neon Babylon rotating slowly beneath them.

Instead of a Pleasure Dome, *The Trip* offers a painted hippy shack with a handwritten sign, 'Psychedelic Temple', tacked up sideways on the front door. Inside, Dennis Hopper and about a dozen other actors are lounging about, sharing a single joint. Peter Fonda shoots television commercials, and his marriage to Susan Strasberg is over. He is taking LSD to gain some insight into himself. 'I never saw this before,' he murmurs when the acid first takes effect. 'I never saw that before.' The rest of the movie documents his experiences in a loose sequence of dreams, encounters and hallucinations. On show is a representation not of the ecstatic but the forbidden. Props, sets and costumes are lifted from Corman's drive-in adaptations of Edgar Allan Poe, creating a hallucinatory experience from the leftovers of old horror movies without the horror. Peter Fonda gasps for breath and rolls his eyes — the Purple Death has claimed another victim. Whereas Anger confronts his audience with cinema as a form of collective hallucination, Roger Corman

has created a film that undergoes the hallucinatory experience on behalf of its viewers and then reports back to them on it. Newspaper headlines and editorials tell the rest of the story. From their narrow perspective, 'underground' means weird cinematic rituals composed of coloured lights, psychedelic patterns and a hint of nudity. The psychic dislocations of *The Trip* consequently do not lead to the cinematic arcana of Kenneth Anger but to something more closely resembling a dream sequence directed by Ray Dennis Steckler. Right down to the obligatory dwarf in mediaeval homespun, *The Trip* represents the audio-visual wreckage of 'the Holy Trance called High' and all that is left behind by the experience. Never have symbolic systems been read so literally. Behind the blown mind is an erased presence. Siegfried leaves himself open to his fatal wound once again. As if to labour this final point the audience gets to see the whole movie again, sliced up into tiny flashing segments, right before the end.

<div align="center">••• ✠ •••</div>

Will Peter Fonda go back to directing TV commercials once his trip is over? Almost certainly — in 1960s LA, the blown mind is the norm.

The
Eighth Gullet
Continued

From Flesh and Innocence...
Frankenstein Created Woman

••• ✝ •••

Pornography, like any other technology that is used up at the moment of experience, ages badly, stranding bodies and pleasures in time. Starting in July 1967, Warhol supplies the Hudson Theater on 44th Street off Times Square with his own brand of sexploitation movies. Originally opened in 1903, the Hudson Theater, with its friezes copied from Nero's Golden House and the Baths of Titus plus its black marble box office decorated with bronze heads of Mercury, has an elegant opulence that once saw much better days. The current owner asks Warhol for something similar to *I, a Woman*: a Danish-Swedish co-production that has been doing great box office in the US. North American rights to *I, a Woman* are acquired by Radley Metzger, who cuts the running time and markets it as an art house sex movie. 'From Sweden...A totally new concept in artistic motion pictures for adults!' the poster copy promises. Herschell Gordon Lewis makes his own

version of *I, a Woman* under the pseudonym 'Armand Parys'. *The Alley Tramp* stars Julia Ames as a teenage nymphomaniac. 'I'm a woman!' she screams at her mother, 'And I'll do as I please! And you won't tell me what to do!' The dramatic impact of this outburst is lessened by Ames visibly glancing down at her script between delivering each line. 'Marie learned that there was no beginning to sex and there was no end!' proclaims *The Alley Tramp*'s trailer, written and read by Lewis himself.

'The people who used to do girlie movies copy our movies now and they're really good,' Warhol says. 'Oh, it's real dirty. I mean I've never seen anything so dirty. They copy our technique.' He offers the Hudson *I, a Man*: a feature-length movie based around a series of vaguely sexual encounters between actor Tom Baker and a succession of women. 'One or two of them look as if they might have had a bath lately, unlike the entire cast of *The Chelsea Girls*,' *The New York Times* sniffs. Featured players include *Vogue* cover model Ivy Nicholson and 'Valeria Solanis' in her one and only Warhol movie; the former tries to marry Andy Warhol, while the latter will empty a revolver into his stomach and chest. 'In the weirdest scene of all, a mock séance,'

XXVII
Eighth Circle: The Eighth Gullet Continued

The New York Times continues, 'Ingrid Superstar, a redhead, shrieks at John Wilkes Booth, "Why did you shoot Lincoln, why did you shoot Lincoln?" Maybe Mr. Warhol will fill us in next time.' But Valerie Solanas gets her shot in first.

'So Warhol is big on 42d St. in New York, where there's an inexhaustible supply of dirty old men of all ages, willing to be incredibly bored for hours on end in the futile hope of getting a cheap voyeuristic thrill,' Roger Ebert writes in the *Chicago Sun Times*: An 'elaborate, deliberately boring joke' on their audience, Warhol's sexploitation films exude a casual aesthetic contempt. 'Typically, the camera freezes interminably by a bed or couch until a beep-beeping sound-track accompanies rapid shots of flesh,' notes *The New York Times* of the visual action in *I, a Man*. This 'beeping' tape jerk heard on the soundtrack is a result of 'strobe cutting' in the camera, creating an alien insect-like chatter, chopping together words and movement with pale blurred flesh. 'Don't you ever have anything new to say?' Stephanie Graves asks a half-naked Tom Baker on her penthouse terrace. It is night, and car headlights speed by on the freeway below amidst the jump cuts. They make out a little. It is a warm night but everything in *I, a Man*

feels cold and distant. In comparison, Valerie Solanas' scene with Baker is full of wiry nervous intensity. 'I can't figure it out,' she exclaims, 'you're a fink — help me out — what's my motivation?' After repeated attempts to grab at his ass and his abs, Valerie leaves the set. 'I wanna go home,' she says. 'I wanna beat my meat.'

Warhol confides to an interviewer that 'we have cops coming up here all the time, they think we're doing awful things and we aren't.' He visits the Hudson Theater 'to see if the audience was laughing or jerking off or taking notes or what, so we'd know whether it was the comedy, the sex or the art they liked.' Most of them are laughing. 'Those Warhol films were real events,' an audience member recalls. 'They gave new meaning to sticky floors.' Meanwhile Warhol supplies the Hudson Theater with *Bike Boy*. Cast as a nameless 'Motorcyclist', Joe Spencer has a swastika tattooed on his arm but no actual motorcycle. He is reading the *Daily News* while Ed Hood looks on. Joe mumbles something about 'Rockwell.' Ed thinks he is referring to Norman Rockwell, the American painter but then examines the headline on the front page more closely — 'SNIPER SLAYS NAZI ROCKWELL: Former Pal Held as Assassin.' Joe means George Lincoln Rockwell,

founder of the National Socialist White People's Party in America, who is gunned down on 25 August 1967 while coming out of an Econowash Laundromat in Arlington, Virginia. 'You ever know him?' Ed Hood asks Joe. 'No,' says Joe, 'did you?' 'Sure,' comes Ed's highly improbable reply. *Confidential* magazine features a poster for the Hudson Theater run of *Bike Boy* together with a picture of Warhol on its cover. 'Coming: Homosexual Action Movies' reads the strapline.

Bike Boy is quickly followed by *Nude Restaurant,* which displays little frontal nudity. Viva, Warhol's latest discovery, will note in her fictionalised memoirs that during the filming 'there were about twenty reporters there, all sitting in a row in the back of the restaurant taking notes.' The performers hide their genitals in black bags. Viva records that these coverings are 'supposed to be a joke, a take-off on the "censored" black patches you see on movie posters.' The parody of pornography, even in its mere pretence at being a dirty movie, turns instead into a parody of cinema. 'They do not act,' Stefan Brecht remarks of *Nude Restaurant*'s performers, 'the camera does not film, the cutter did not make a movie out of the footage.' There are more beeps and strobe cuts. Brecht notes

of the late-night screening of *Nude Restaurant* that he attended at the Hudson Theater that 'only a few men, looking like business men, attended, watching the self-consciously unconcerned naked figures, listening to the desperately harsh "bright" voices delivering the monologue.' At the end of his visit to the Hudson Warhol recalls that 'the box office guy told us that during lunch hour was when business was best'. Warhol casts Viva in the rest of his sexploitation films for the Hudson because she can take her clothes off, step into a bathtub and 'talk intellectually.' Brecht remarks that *Nude Restaurant* 'is neither shallow nor profound but flat: in the surface on which it is projected.'

The film ends rather abruptly with Viva asking off-screen where the Federal Building is.

XXVIII
Eighth Circle

The
Ninth Gullet

Dr Terror's
Gallery of Horrors

··· ✝ ···

Out in the middle of nowhere, veteran comic actor Mantan Moreland sticks his head through an open window in an old empty-looking house. A rare black presence on the Hollywood screen, Moreland is best known for being the only character smart enough to act scared in the 1941 Monogram release *King of the Zombies*. Still scared after all these years, he gets a net thrown over him then stabbed in the face and his ear sliced off. A house divided will soon haunt itself. Moreland may be dead, but he's not alone. Back in 1941 horror legend Lon Chaney Jr. starred as Universal's *The Wolf Man* for the first time. Now Chaney is busy lugging Moreland's corpse down to the basement. 'Frankenstein, Dracula and even the Mummy are sure to wind up in somebody's tummy,' he chortles at the start of *Spider Baby*, the feature-length debut of Roger Corman alumnus Jack Hill.

Too graphic to be a comedy, too much of a cartoon for true horror, *Spider Baby or, the Maddest Story Ever Told* pits Old Hollywood against the New Sensitivity — and if this seems a little late, remember that the movie was actually completed back in 1964 but never released after the original producers went broke. Now *Spider Baby*, AKA *The Liver Eaters*, AKA *Cannibal Orgy*, slips out at the end of 1967 on the bottom of a poverty-row double bill — which seems entirely appropriate for a murderous story with regression as its main theme. Made when *The Munsters* and *The Addams Family* were still new to national TV, *Spider Baby* is one of those movies that you don't so much watch as feel under your skin. Virginia, Elizabeth and Ralph suffer from a progressive form of age reversion that causes them to regress 'beyond the prenatal to a pre-human condition of savagery and cannibalism.' Bearing the stigma of white trash and royalty alike, they are 'the unfortunate result of in-breeding': aging *enfants terribles* who act upon every urge and impulse with an innocent simplicity. Lon Chaney looks after them in the lonely old house, which they share with colonies of spiders, rats and stuffed birds, a clutch of flesh-eating ancestors locked up in the basement and the decomposing remains of their father still on his deathbed.

XXVIII
Eighth Circle: The Ninth Gullet

Played by Carol Ohmart from William Castle's *House on Haunted Hill*, 'Aunt Emily' dances around her decrepit bedroom in black stockings and negligee while Ralph watches from outside the window with predatory glee. They serve bugs, weeds, mushrooms and roasted cat to their guests for dinner — 'we're vegetarians,' Elizabeth explains, 'we don't eat dead things.' Cinema is the secret means for a controlled liberation of lust — giving us precisely what we fear the most. 'How many times do I have to tell you?' an exasperated Lon Chaney Jr. explains once again to his young wards, 'just because something isn't good doesn't mean it's bad.'

The consumption of Old Hollywood continues near the end of 1967 with John Vaccaro's production of *Conquest of the Universe* at the Bouwerie Lane Theater in downtown New York. Staged by the Playhouse of the Ridiculous and starring Warhol superstars Taylor Mead, Ondine and Ultra Violet, this is a savage satire on *Flash Gordon Conquers the Universe* in which Flash is cheerfully reincarnated as the vicious Tamburlaine attempting to dominate outer space through sex and imperialism. The original script by Charles Ludlam is a cutup of Marlowe's *Tamburlaine* with lines from Shakespeare and Hitler, TV commercials and newspa-

per small ads. 'The play's style,' Stefan Brecht observes, 'does not relate to science fiction (which is serious). It seems to me not unlike that of American cheap pornography (which is not serious, but vital and desperate).' Its text and premise supply acceptable entertainment for a society whose members have spent too long in front of their television sets watching strange people burn in exotic locations. Brecht finds in *Conquest of the Universe* 'a *naivete* which makes Americans so disgusting from Hanoi to Paris and London' transformed into 'the filthy play of wilfully childish persons.' The cast of *Spider Baby* seem to have found new playmates.

In the lead as Tamburlaine, Brecht discovers Mary Woronov. 'Tamburlaine (fascism, militarism, violence and stupidity) conquers the solar system without much opposition other than private, his opponents a huddle of queens,' he writes of her performance. 'With hysteria, paranoia, she plays a bare core of sadist energy. Her Tamburlaine "comes in bullets," distraught only by his lack of issue.' The media firestorm of Vietnam sweeps through every word of *Conquest of the Universe*. Director John Vaccaro fires playwright Charles Ludlam, along with several cast members, from the production. Ludlam and the dismissed performers retaliate by staging their

own version of the play under the title *When Queens Collide* in the New Year of 1968. No longer contained by strategies of distance and counterinsurgency, Vietnam is revealed as a failure of culture: a collapse not of policy but of an entire hierarchy of values.

By late 1967, Warhol sees the Factory as a vacuum: empty and separate from the outside world, where he can make his movies undisturbed. 'The first principle was chaos,' Factory member Billy Name explains. 'It wasn't the type of chaos of being jumbled up. Mixed up — it was chaos as a pure wedge in the cosmos. Like the deep valley where nothing is defined.' It is a matter of perception: another form of cinema. To frame such a primary condition is to flirt with danger. A fragment implies a whole even as it remains a fragment. Other fragments imply an entire galaxy of wholes. Chaos exists within the undifferentiated matter of Trash. Psychic dislocation founders between what is true and what is not. Violence moves in and out of the collective frame of reference. Chaos endures.

The more unbearable an experience actually is, the more we seek to diffuse and deflect it. Accommo-

dation becomes another form of prohibition. In his memoirs Warhol identifies the woman who shot him as 'Valerie Solanis': a composite of her real name and 'Valeria Solanis' — the name under which she appears onscreen. *The New York Post* for June 4 1968, with its headline ANDY WARHOL FIGHTS FOR LIFE on the front page of the Late Edition, also identifies his attacker as Valerie Solanis — before correcting it to Solanas in time for the final Closing Stock Prices edition. The simple elegance and brutal logic of the gunshot define the times. Warhol dies briefly on the operating table but is swiftly revived and his body sewn back together again 'like a Dior dress.' This is all that prevents Andy from joining Malcolm X, George Lincoln Rockwell, JFK, Bobby Kennedy and Martin Luther King. Violence, assassination and gunplay constitute the new sexual cinema of the masses; rage buries itself deep within the void of pop trivia.

Backlit by the fires of Vietnam, Trash is culture retold as a joke — and, like all jokes, it becomes a harbinger of doom.

The
Tenth Gullet

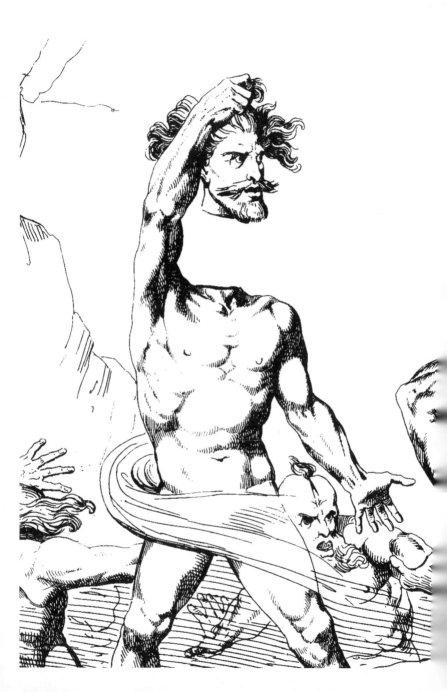

The Profound
Desires of the Gods

··· ✝ ···

One block up from the Hudson Theatre on 43rd Street stands the Park-Miller playhouse. It screens art house movies after Warhol's shooting, starting with the premiere of his sexploitation western parody *Lonesome Cowboys*. Soon it is running a triple bill of Anger's *Fireworks*, *Scorpio Rising* and *Inauguration of the Pleasure Dome* packaged with a selection of gay porn loops. There is little difference between the Park-Miller and the Hudson Theatre — the two are easily confused with each other, and the Park-Miller is briefly renamed the 'Hudson on-the-Avon' when the latter closes. It quickly becomes a sexual landmark. 'I saw it as soon as I walked into the Porter Mills gay blue movies on 43rd between sixth and seventh,' William Burroughs writes from New York, so excited by what he had seen that he gets the name wrong, '...some trailer that shoots its wad all over the screen close up.' Burroughs sees the future coming out of the frame. 'I think we are all out of business,' he reflects, '...writers.. painters.. photographers and above all and very soon film-makers.'

A cowboy points his gun into the camera and fires repeatedly at the very end of *The Great Train Robbery*, a Thomas Edison movie from 1903. Members of the audience duck to avoid the phantom tracery of bullets that exist only as projected billows of smoke pushed out towards the flat screen. Images tear through darkened space. The real action at the Park-Miller is taking place off the screen. Movies offer limitless opportunities for cruising the darkened aisles and balconies. Sticky floors lead to sticky meanings. In the 1968 movie *The Detective*, Frank Sinatra becomes the first Hollywood actor to use the word 'semen' onscreen.

Edited together from sequences filmed during the summer of 1967, *The Loves of Ondine* starts with its titular superstar experimenting with heterosexuality in a series of encounters with women. Cut to a group of young Latino men, billed as 'The Bananas', having a food fight in a large East Hampton kitchen. 'They dump quarts of milk over each other's heads,' runs one account. 'They grind mashed lettuce leaves into their groins and buttocks. They fling flour on the walls. They force-feed each other pickles. They squirt orange juice at each other's rear ends.' This takes us back to the Walpurgis Party episode in Anger's

XXIX
Eighth Circle: The Tenth Gullet

Scorpio Rising where members of the bike gang 'have started to smear hot mustard on the bare crotch of one of their comrades'. One of the Bananas is Venezuelan performance artist Rolando Peña, also known as the 'Black Prince', who publicly dowses himself in crude oil. Meanwhile, in the name of male banality, the bikers in *Scorpio Rising* continue 'pouring on the mustard.'

Ondine finds himself excluded from his own orgy in the movie that bears his name 'because', as he sees it, 'Paul is a garbage collector, to be perfectly frank with you. He collects every piece of garbage he can get.' Paul Morrissey has taken over the making of Warhol's films by this time and is therefore responsible for the kitchen orgy. *The Loves of Ondine* opens in Greenwich Village on 1 August 1968 at the New Andy Warhol Garrick Theatre, renamed in the artist's honour while he recovers from his shooting in hospital. The film is effectively Ondine's last for Warhol as the chaotic superstar is banned from the Factory premises because of his angry outbursts. Meanwhile Warhol concentrates on producing a colourful set of high contrast images of the Kennedy assassination under the title *Flash — November 22, 1963*.

25.10.15 — Zurich Kunsthalle: John Waters, Eat Your Makeup *(1968) 16 mm b/w with tape-recorded soundtrack — responds to a specific USA underground movie aesthetic that is emphatically not European but low-budget Hollywood. 'Help me' — crawling through the desert, 'Rumble' by Link Wray, 'Extreme Unction' as drag name, 'Hail Mary' rosary, bondage and riding crops. Hip young things go to the 'Horror House' in mod clothes — 'It'll make you sick' — hung with skeletons, hookah pipe, girl guide continually saluting with flag. Girl in shopping cart laughs and screams. 'Surfin' Bird' by the Trashmen. 'Scare o Chair 25c' — carnival sideshows — Divine selling kisses in a miniskirt and op art raincoat. Decapitating baby dolls with an axe cutting them into pieces. Divine as Jackie O in a recreation of the JFK assassination with Wagner's Siegfried Funeral March on soundtrack — Judy Garland 'Get Happy' — tape jerk on recorder — women forced to model themselves to death. Change of clothes and tiara to 'Auf Wiedersehen' — Snow White revived with a kiss.*

'He was one of those greasy, repugnant, long-haired creatures we tend to overlook in our soft focus

Eighth Circle: The Tenth Gullet

nostalgia for the 1960s,' someone will write about John Waters. 'He was...trouble.' During the early 1960s Waters comes down regularly from his native Baltimore to attend underground movie screenings in the fleapits, theatres and cellars of Manhattan. His early films such as *Hag In A Black Leather Jacket* from 1964 and the 1966 three-screen *Roman Candles* show the influence of Jack Smith, Ron Rice, the Kuchar Brothers, Andy Warhol and Kenneth Anger. Forthcoming Waters productions will include *Mondo Trasho*, *Multiple Maniacs* and *Pink Flamingos*.

The roaring of motorcycles echoes in the darkness. Some psychedelic poster art spins out on the screen. 'We are the Hellcats nobody likes,' a girlie chorus sings with stirring lack of conviction. 'Man-Eaters on motorbikes.' The lyrics are by Herschell Gordon Lewis using his Sheldon Seymour pseudonym again. The film is *She-Devils on Wheels*: directed by Lewis under his real name from a script by his wife Allison Louise Downe, whose screenwriting credits include *Blood Feast*, *Scum of the Earth!* and *The Gruesome Twosome*. This may well be the Honda moped of biker movies. The all-female Man-Eaters wear club colours that look as though they were sewn together in high

school: their patch featuring a pink pussycat with a black bowtie. This is the kind of production that shows you what a motel table lamp actually looks like. The entire cast acts as though they were in a dinner theatre production of *South Pacific*. They smoke a lot of moody cigarettes — sometimes there is blood and some violent ugliness. Action is a vacuum in this movie; the eye dwells on garbage cans and how a pair of pink go-go boots are pulled on — or the female biker absent-mindedly patting and caressing a motorcycle headlight in the foreground of a bondage scene. Things become literal. A tailor's dummy is dragged in chains around a darkened airfield runway. 'Hamburger!' a gang member yells off-camera.

The Walpurgis Orgy continues with biker movies such as *The Hellcats*, *The Savage Seven* and *The Mini-Skirt Mob*, released on a double bill with *Angels from Hell*. The latter involves the usual rapes, parties and knife fights, plus a visit to a movie star's Hollywood pad and a hippie celebration in the woods. It also boasts Sonny Barger of the Oakland Hell's Angels as Story Consultant and some original Von Dutch artwork. '*Mini-Skirt* is sickening,' declares *The New York Times*. '*Angels* is merely dull.'

··· ✝ ···

Angels also ends on a quote from the Old Testament: 'Come now and let us reason together Isaiah 1,18.'

The
Tenth Gullet
Concluded

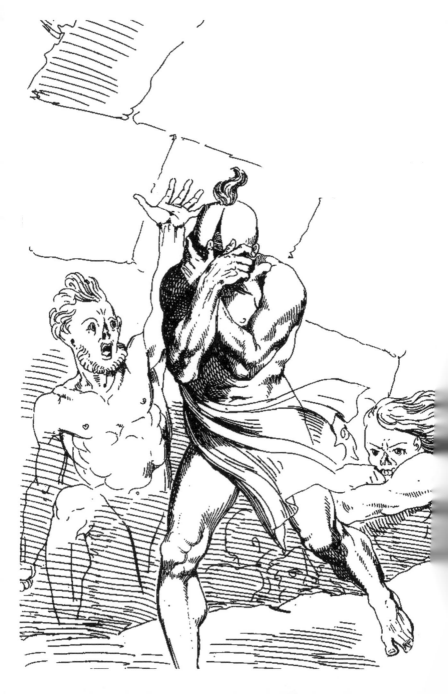

The Inferno
of First Love

Accounts place Charles Manson on Sunset Strip in 1968 hanging around with members of bike gangs such as the Straight Satans, the Gypsy Jokers and Satan's Slaves. He also spends a lot of time at the Sunset Boulevard home of Dennis Wilson of the Beach Boys. Thanks to Dennis, Manson gets to record some of his own songs in the home studio of brother Beach Boy Brian Wilson. Manson's family of runaways and followers brings a spectacular outbreak of gonorrhoea to both households. Dennis picks up the tab for its treatment, while Brian cowers in his bedroom and his wife Marilyn makes sure the toilets are 'disinfected and scoured several times.'

Manson knows that there can be no compromise with straight society — and this is what will make him famous. He had been locked up in the Federal Penitentiary on McNeil Island when the Beach Boys were

celebrating surfboards, hot rods and the California sun. Charlie may have showed up late for the beach party, but he is there for the leftovers — girls picked up by the roadside, music and movie industry rejects, dope dealers and drifters looking for something to believe in. A fast-talking hustler who can never get enough attention, Manson opens up the negative space inhabited by the mass media. The record, film and television industries meet within, but cannot contain, his philosophy. He wants to spread his message through his music. 'Submission is a gift,' he tells the Beach Boys, 'give it to your brother.'

Trash is mistakenly perceived as the last stage in an eternal process — a closure, which is also a small moment of horror. Trash indicates a direction, not a destination. Its existence is always premature: a restless innocence that takes over matter. 'Trashing', living off the street and out of dumpsters, comes into its own in the 1960s: the disposable item as the throwaway art form of the age. According to Family member Susan Atkins, AKA Sadie Mae Glutz, 'supermarkets all over Los Angeles throw away perfectly good food every day, fresh vegetables and sometimes cartons of eggs, packages of cheese that are stamped to a certain date, but

the food is still good, and us girls used to go out and do "garbage runs"'. One particular waste bin at the rear of the Market Basket in Chatsworth is regularly 'packed solid with wooden crates tossed askew, cardboard boxes, celery, lettuce, sliced display melons, slightly mutant bell peppers, corn husks, pink unripe tomatoes, raggedy squashed balls of lettuce.' Manson's girls take Dennis Wilson's Rolls Royce on their garbage runs, piling up the backseat with discarded produce. 'And they lived on the garbage dumps of America, the food that America's thrown away for years,' reveals Phil Kaufman, a former Manson prison-mate and producer of his music.

'Dope addicts! You think you can do anything you damn please!' an irate driver yells at a deaf Susan Strasberg at the start of *Psych-Out*, a hippie exploitation flick produced by Dick Clark, the father of *American Bandstand*. She's out on the streets of San Francisco looking for her runaway brother who has found God in a sugar cube laced with LSD. Music for this Haight-Ashbury travelogue includes 'Incense and Peppermints' by Strawberry Alarm Clock and a score by Ronald Stein, who wrote the music for *Spider Baby*. 'Let's kill her and eat her,' jokes a bunch of hippies when they discover that

Strasberg can't hear them. Soon to be a beloved son of the mass media, Charles Manson has taken in the whole scene; hippies, bikers, drugs, music and sex create a living cinema to be acted out according to his purpose. Fame, as always, is the modern form of salvation. 'You could feed the world with my garbage dump' Charlie sings in one song recorded over the summer of 1968.

Human leftovers gather in George Romero's *Night of the Living Dead,* where flesh-eating ghouls storm the lonely and abandoned houses of the American heartland, killing and devouring their victims. This is a garbage dump of a movie, shot in Pittsburgh on the lowest budget black-and-white stock. The ghouls are played by non-speaking locals, who look like your parents, your friends and family. They have clearly been to school and held down jobs — you can tell by the way they dress. 'Yeah, they're dead,' an armed sheriff assures the news media. 'They're all messed up.' The living dead are no longer responsible members of society. Unlike the sleepwalking zombies that scared Mantan Moreland back in the 1940s, these ghouls do not labour in the fields to order — they only go out to eat.

XXX
Eighth Circle: The Tenth Gullet Concluded

This mysterious phenomenon has proliferated quickly, taking over the media, gripping the nation with terror. 'They're coming to get you, Barbra,' a man taunts his adult sister in an empty graveyard, trying to frighten her. 'They're coming for you, Barbra. Look...here comes one now.' He turns out to be absolutely right — and dead in a matter of moments. Come one, come all. The dead are returning to life in ever-greater numbers, unclean and corrupt, sustaining themselves upon the flesh and blood of the living. They are a strain of monochrome bacillus eating its way through the film's grainy emulsion. Images are blurred and decomposed: the feel of cheap 'underground' filmmaking done on the run is combined with the immediacy of Vietnam War coverage happening before the audience's very eyes. 'Don't look at it,' Barbra is sternly advised by Ben, who stabs a zombie in the forehead with a tyre iron. She turns her face away. The blood in this movie is slow-running Bosco's Chocolate Syrup, and the flesh is cooked ham, bones and entrails supplied by a local butcher, who also doubles as one of the living dead.

After the nudie-cutie and the roughie, George Romero's flesh-chewing zombies constitute the final exposure and damaging of the skin on film. Cinema resurrects

itself as the last mass erotic rite of pop culture. 'He grabbed me! He grabbed me and he ripped at me! He held me, and he ripped at my clothes!' Barbra wails, hugging herself with bony fingers as she describes being attacked by the ghoul in the graveyard. Ben frowns. 'I think you should just calm down,' he advises, trying to reassure her: the only black face in a world full of white zombies. Erotic rites are never beautiful, despite the secret wishes of the public — they must expend themselves as ugliness and waste. A nude female zombie wanders past the camera; surgery patients emerge from the night — mass murder is everywhere. *Night of the Living Dead* captures the exhaustion of Eros as film: the rotting putrefaction of the body trapped in time. The ghouls could be unwashed hippies, greasy bikers or sexual perverts cruising through the dark.

'We don't know what kind of murder-happy characters we have here,' a police chief cheerfully concedes, while America eats itself.

Into the
Central Pit

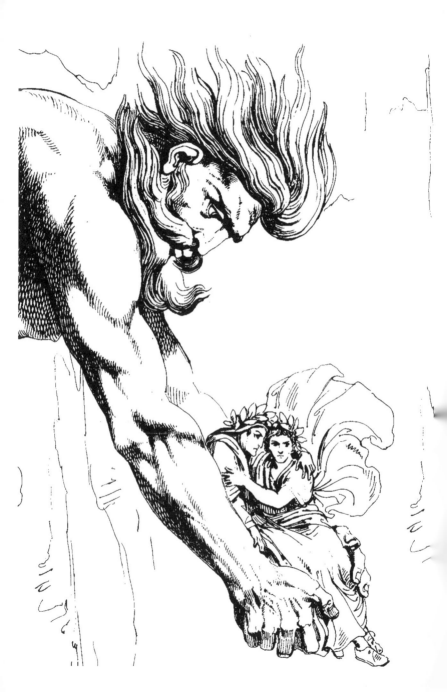

Giant monsters battling at the end of time

••• ✝ •••

Akio dreams about finding a star where people are smart. 'Just think,' he says to his American friend Tom. 'No more wars on their planet and no more traffic accidents.' They travel in a cheap plastic spaceship to a world ruled by Guiron, a giant monster with a head like a steak knife. In a futuristic city of pods and domes, two female space aliens decide to eat the boys' brains in order to learn more about Earth — 'just as our bacteria do here to become higher animals.' They get as far as shaving Akio's head. The only creature in the universe that can stop them is Gamera: a giant sabre-tooth, fire-breathing flying turtle from outer space.

✦✦✦ ✚ ✦✦✦

'There was a huge fall in the average age of Godzilla fans,' according to veteran *kaiju* director Ishiro Honda, 'so Toho decided it would be a good idea to make him more heroic and less scary. I didn't like the idea, but I couldn't really oppose it.' Godzilla consequently becomes a friendly protector to all children, just like his rival Gamera over at Daiei studios. In 1969 Gamera's latest adventure is released as *Attack of the Monsters* in the United States, where it is quickly sold on to TV. Even for a low-budget *kaiju* movie, *Attack of the Monsters* is low budget. The giant monsters look like plastic bath toys being bashed together whenever they fight. The characters' lip movements rarely fit with the words; and the words rarely fit with what is happening. *Kaiju* movies dubbed into English are legendary for the pop poetry of their dialogue. 'Your mother sure makes donuts real great,' Tom confides in Akio. 'I'm starving just at the thought of it.' Gamera works stiff arms that only move at the shoulder and a jaw that opens and closes flaccidly. His eyeballs are hard and round and unnaturally white. 'We got to the point where we could control the laws of nature with advanced electronics,' one of the female space aliens explains. 'But then a mixed-up computer brought calamity. We found to our regret that it made uncontrollable monsters as well.' 'Gee!' says Tom. 'Whoa!' says Akio.

To repeat: cinema is the coordinated liberation of lust: a restructuring of chaos that gives us what we fear the most. This is, after all, the Age of Aquarius — the new Aeon of Horus, 'the Crowned and Conquering Child', as set down by Aleister Crowley in his *Book of the Law*. Just as Lucifer rose up in Heaven against a jealous and angry God, the New Age has no choice but to overthrow the repressive strictures of the Old. Uncontrollable monsters are let loose. Kenneth Anger plans to invoke the rebellious 'Crowned and Conquering Child' on film, just as soon as he can find his Lucifer. Disaster reigns. Let joy be unconfined.

The complete rejection of all rules is a satanic act of pride, clothing itself in grease and tattoos and barbaric insignia. The California Hell's Angels are the new nobility: an inversion of the law that embodies the law. Von Dutch stripes motorcycle gas tanks for the Oakland Angels. Former Warhol superstar Edie Sedgwick hangs out with the Vikings MC while undergoing psychiatric treatment following her arrest for various drug offenses. Ed 'Big Daddy' Roth runs with an outlaw bike gang, publishing a magazine devoted to 'choppers': the motorcycle equivalent of the custom car. If you really want to know what's happening in

society, he declares, just take a look at the junkyards and scrap heaps. The trash piles of America will reveal what is actually going on.

Trash becomes the eternal recurrence of filmed experience: a nightmare of the familiar. Aging child monsters Ralph and Elizabeth from *Spider Baby*, or at least the actors playing them, are back again in Jack Hill's latest feature. Featuring Sid Haig and Beverly Washburn in supporting roles, *Pit Stop* is a *charioscuro* newsreel of a movie exposing life on the motor racing circuits of Southern California. A loose plot concerning greed and ambition links together stark scenes of automotive carnage. At the Ascot Park Figure Eight Races, cars collide noisily with each other in the floodlit night. 'There's a suicide born every minute,' a promoter spits cynically as metal, flesh and bone smash together. 'This machinery owns us,' remarks a female mechanic with weary bitterness. George Barris appears in a brief cameo filmed at his Kustom City shop. A young punk racer reads *Hot Rod* magazine in a cheap motel room while his bored girlfriend undresses. Car parts are gouged from wrecks in an auto salvage yard.

XXXI
Into the Central Pit

More documentary than drama, *Pit Stop* captures the state of Trash culture in California by 1969: tired, worn, cynical — unable to stop. A dreamlike montage of dune buggies racing across the rolling emptiness of Imperial Valley to the sound of psychedelic guitar rock, the sand fanning out from beneath their fat rear tyres, feels like a moment of release. 'Is there any place left in this world where there aren't any old beer cans?' the punk racer asks disgustedly, staring out across the dunes. At the Butler Buggy Shop on Topanga Canyon Boulevard, Charles Manson pays cash for a couple of custom dune buggies to add to his collection of desert racers hidden out at the Spahn Movie Ranch with a stash of stolen Volkswagen and Porsche parts. Charlie takes it all in — as always. His personal dune buggy comes equipped with machine-gun mounts at the back covered in real ocelot fur, plus a sword in a metal scabbard affixed to the steering column — some of his girls have decorated the rails with locks of their own hair.

One afternoon in 1969 Manson drives out to Devil Canyon, taking with him Kenneth Anger's most recent Lucifer, a young hippie musician named Bobby Beausoleil, AKA 'Cupid.' Outside an old abandoned mine, claiming that Cupid knows too much, Manson

threatens to slit his throat. Cut badly by the knife-headed Guiron, Gamera's wounds spurt blue blood. The space debris of pop culture is growing hard and cold. One of the female space aliens is badly injured during the last giant monster fight. The other female space alien draws a ray gun and points it at her.

'You know the rules of our planet,' she says. 'The useless have to go. It's the only solution.'

Caïna to Antenora

Betrayal is a form of rebellion — and so too is pride

••• ✠ •••

Picture this epic exploitation movie scene — a squadron of dune buggies roaring across the dry lakebeds and salt planes of Death Valley in advance of Armageddon. Charles Manson is leading his family out into the desert, where he has found a hole that grants secret access to a lost civilisation hidden deep inside the centre of the earth. Charlie and his chosen followers will live down there while the coming race war between black and white destroys the old world order. Incarcerated in the Sybil Brand Institute during 1969 on charges of auto theft and first degree murder, Susan Atkins, AKA Sadie Mae Glutz, pitches the scenario to a fellow inmate. To help get the movie started, establishment 'pigs' are being killed in their homes by members of the Manson Family, who plant incriminating evidence pinning the murders on the Black Panthers. The Beatles' *White Album* told them to.

It is the inexorable law of the universe that everything must perish. 'You have to have a real love in your heart to do this for people,' Sadie Mae says, explaining why Sharon Tate and all of the other beautiful people at 10050 Cielo Drive had to die that night in August. And Leno and Rosemary LaBianca. And Gary Hinman. And all the others. You have to love someone so much that you can tear them open and gut them upside-down and inside-out — because in the end you are only killing a part of yourself. Manson is arrested for the theft of a '69 Volkswagen found, stripped of its parts, at the Spahn Movie Ranch, where the dune buggies are being assembled for the wild ride to Death Valley. In September the police haul back from the desert 'a gold flaked 1962 Volkswagen dune buggy stolen in the San Fernando Valley and a yellow 1967 Volkswagen dune buggy stolen in Culver City' as part of their investigation into the Family.

Also jailed on a murder charge in the summer of 1969 is Kenneth Anger's Lucifer, accused of killing Gary Hinman: an act committed on Manson's orders. Bobby Beausoleil had split with Kenneth Anger, taking with him the existing film, tapes and props for the director's maximum opus *Lucifer Rising* — or at least this is

XXXII
Ninth Circle: Caïna to Antenora

what Anger claims. Manson is supposed to have them buried out in the desert awaiting a ransom for their return. Anger attempts to make Lucifer rise again from a bin full of outtakes and offcuts shot mostly around late 1960s San Francisco. *Invocation of My Demon Brother* is an angel dust version of *Inauguration of the Pleasure Dome* down to the same red-tinted footage from an early Hollywood adaptation of Dante's *Inferno* that appears in both.

Anger calls *Invocation* his 'war film': a short abrasive male rite composed of unrelated fragments featuring a ragged pantheon of creeps and imposters. Founder of the Church of Satan Anton Szandor LaVey flaunts a black cowl and red plastic horns. Susan Atkins worked briefly as a go-go dancing vampire in his San Francisco Topless Witches' Review; LaVey claims she was strung out most of the time. He unfurls his cape in the grand Bela Lugosi manner. Beausoleil poses in a top hat, smiles and flutters a set of tiny wings; the word 'FLASH' appears in red diagonal letters on a poster across the back wall while Cupid's freeform acid music group, the Magick Powerhouse of Oz, perform. Mick Jagger supplies the movie's soundtrack improvised on a Moog synthesiser — it lasts eleven minutes and is very 'now.'

Ritual gestures are intercut with psychedelic optics, close-ups of tattoos and exchanges of meaningful glances: a seething violence seeps through every edit. Soldiers jump from a helicopter in Vietnam; the Rolling Stones perform soundlessly at their Hyde Park free concert; Hell's Angels appear in a halo of flames, patrolling the stage — 'but of course they're not the real Hell's Angels,' one of the Stones later reveals, 'they're completely phony. These guys in California are the real thing — they're very violent.'

The Dionysian is a necessary indulgence of Apollonian order, its rites permitted only in what appears to be an enduring system. The piling up of bodies and pleasures constitutes a longing for chaos, not its permanent imposition. Tracing their name back to a movie melodrama about daredevil aviators produced and directed by Howard Hughes, the Hell's Angels were always Old Hollywood. Biker films released in 1969 include *Hell's Belles*, with a soundtrack by Les Baxter, and *Satan's Sadists*, starring Russ Tamblyn, whose previous movie credit is *kaiju* flick *War of the Gargantuas*. 'I was born mean,' a lone vocalist mourns as Russ and his gang roar down an empty desert highway. 'By the age of twelve I was killing — killing for Satan.'

✦✦✦ ✚ ✦✦✦

The Walpurgis Party is set to erupt again at the Altamont Speedway in Northern California on 6 December 1969. With the new moon rising in Scorpio, always a sign of violence and disorder, and Mars low on the horizon, a crowd of 300,000 gather to watch the Rolling Stones play a free concert. 'It is impossible to speak of the music that went down without placing it in the context of the violence,' *Rolling Stone* magazine will subsequently report. The speedway at Altamont forms a brooding natural amphitheatre: treeless and bare and littered with the wreckage of cars left over from demolition derbies. Crowded with so much humanity, it becomes a conceptual form of Land Art: a collective industrial hallucination fuelled by a high-octane mix of bad acid, cheap booze and reds. Paranoia spreads in waves through the crowd. Freak-outs, skull fractures and concussions overrun the limited medical facilities. Trash fires are soon burning across the sacred site, the smouldering garbage producing 'a rancid combination of fog, dust, smoke and glare' that makes the tiny stage away in the distance even harder to see. The music is inaudible unless you're right down at the front, which is also where the real Hell's Angels happen to be.

Members of a grand jury empaneled in Los Angeles take a break over the weekend before returning indictments against Charles Manson, Susan Atkins and four other Family members for a total of seven counts of murder and one of conspiracy to commit murder. Amidst the scuffles and yelling and the violence, four people will die at Altamont that Saturday: one drowning; two killed by a hit-and-run driver; and a young black student named Meredith Hunter stabbed and beaten by the Hell's Angels while the Rolling Stones play 'Under My Thumb.' Hunter stood out, wearing a lime green suit with a black hat and a black shirt buttoned to the collar. He had a white girlfriend called Becky. He also had a mother and a sister Gwen, who tells *Rolling Stone* that 'The Hell's Angels are just white men with badges on their backs.'

The front page of the *Los Angeles Herald Examiner* for the previous afternoon had led with 'TATE KILLERS WILD ON LSD, GRAND JURORS TOLD'.

Antenora to Ptolomea

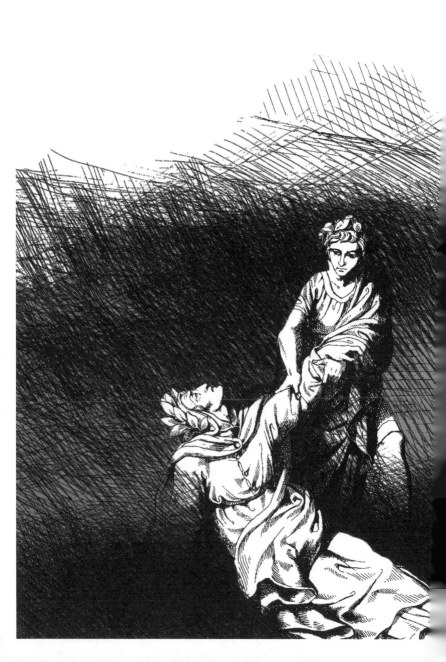

What you cannot know...

••• ✝ •••

'After Altamont, life was one criminal cluster fuck after another,' according to Sonny Barger, who was at the front of the stage when Meredith Hunter died, although he claimed he never saw what happened. Murder is the defining act of a civilisation — recording it on film is the defining act of a culture. The conquest of reality by cinematic means ends with the nihilism of the image: its supreme exploitation. Assembled by Albert and David Maysles and Charlotte Zwerin, *Gimme Shelter* is a feature-length autopsy performed upon the events surrounding Hunter's death. Their cameras catch the victim coming in at the side of the frame around 1 hour and 18 minutes into the movie, his black broad-brimmed hat, black ruffled shirt and lime green suit iridescent in the drab mosh of beautiful people surrounding the stage: one of 300,000 extras about to take over an entire movie. A toxicology screen will reveal that Meredith Hunter was loaded on methamphetamine at the time. There are a lot of faces down there, packed between the Angels and the Stones: they grow prettier the nearer they get to the edge.

The act of seeing with one's own eyes is irrelevant when confronted with death on film. Our impressions of the living are already so fragmented and imprecise, why should our impressions of the dead or the dying be any different? Meredith Hunter raises a gun that seems only to exist on film: a long-nosed .22 pistol similar to one used at Cielo Drive, you can see it briefly silhouetted against his girlfriend's crocheted dress. The Maysles Brothers freeze the frame in the editing suite. Who was Hunter aiming at? Not at any of the cameras recording the scene, that's for sure. This fascination with the shot that was never fired balances Kennedy's cranial wound opening up on film at Dealey Plaza near the start of the decade — cinema played out as sacrificial rite. 'I went over and they had this thing of coffee and...poured it all over to wipe off all the blood,' reveals an unnamed witness to Meredith Hunter's last moments. Under the bright lights the stains stand out like rust on his crumpled muddy lime-green suit while Hunter's body is loaded into a medevac copter. 'Whoever goes to see that movie paid for the Altamont religious assembly,' a newspaper columnist grimly remarks when *Gimme Shelter* gets released in 1970.

Following the sound of rotor blades disappearing into the darkness, the camera focuses on the fans making their way home after the killing: zombie ghosts moving like extras in *Night of the Living Dead*. It's the machines that move the crowds — not the crowd that moves the machines. *Gimme Shelter* is one of the most terrifying horror movies America has ever produced. Sonny Barger calls underground rock station KSAN to defend the Angels' behaviour at Altamont — snorting cocaine before going on air, parts of his wired tirade are featured on the movie's soundtrack. Altamont, he will assert, was 'the end of nothing.' And he is probably right. Trash cinema is a sacrificial mechanism: satire played out with a straight face — for keeps and for real.

Naked and covered in black body paint, her neck hung with heavy steel chains, Haji comes in out of the desert looking like the ghost of Trash Movies Past. She stares straight ahead, barely noticing any of the personalities, pop gurus and scene-makers crowded around her at one of Ronnie 'Z-Man' Barzell's social gatherings in swinging LA. 'Now you're inviting *motor psychos* to your parties?' an uptight lawyer smirks. 'What next?' The hippies and bikers and the countercultural youth

tycoons who used to hang out by Hollywood swimming pools start to disappear in the wake of Manson and Altamont — the studios are no longer returning their calls. Like Antonioni's *Zabriskie Point*, Mick Jagger's acting in *Performance*, the crowd scenes in *Gimme Shelter* and Mae West starring in *Myra Breckinridge*, Russ Meyer's *Beyond the Valley of the Dolls* is another waking nightmare troubling moviegoers in 1970. 'What I see is beyond your dreaming,' Haji informs Z-Man in her only line of the movie, as they survey another party that is turning pilled-up, sour and violent.

Beyond the Valley of the Dolls, like Haji's oneiric vision, is haunted by low-budget memories. Strawberry Alarm Clock once again perform 'Incense and Peppermints', last heard in *Psych-Out*; Michael Blodgett, a bit player in *The Trip*, returns as 'Greek god and part-time actor' Lance Rocke. An unauthorised sequel to the movie adaptation of Jacqueline Susann's *Valley of the Dolls*, this is what plastic looks like when it rots. Old Hollywood has gone slumming on the exploitation circuit, giving Meyer his one chance at a mainstream movie career. Movie critic Roger Ebert is writing the script. 'I don't want you being murdered by any of these

Satan worshippers,' Meyer tells him, putting Ebert up on the second floor of the Sunset Marquis Hotel just off the Strip. The Manson killings ripple through Meyer's party scenes like a bad hallucination.

The entire movie implodes around a private drug orgy that Z-Man throws for a select few at his groovy beachfront pad. They come dressed as cartoon superheroes and ingest hallucinogens in a sequence that is practically a frame-for-frame parody of Kenneth Anger's *Inauguration of the Pleasure Dome*. The stark polychrome lighting and the knowing glances that take in the cinematic space outside the frame are copied directly from 'Lord Shiva's Dream' — but instead of Leoš Janáček's majestic *Glagolitic Mass* on the soundtrack, Meyer substitutes *The Sorcerer's Apprentice* performed in the style of Lawrence Welk. Anger's pagan gods and mythic figures give way to a generic Batman and Robin, 'Superwoman' and 'Jungle Lad.' Where Cesar the Somnambulist pours the divine libation in Anger's Pleasure Dome, Nazi fugitive Martin Bormann looks on in an SA officer's uniform. 'You have to see it to believe it,' one Hollywood queen confides to another during an earlier party scene, invoking cinema's power of invisibility. 'Of course I nearly choked.'

Ebert's script displays a movie critic's weakness for parody: the mix of pop baroque and murky sensationalism becomes a major Hollywood put-on as the big studios go underground. The orgy ends in a slapstick tangle of blood and body parts brought about by the revelation that its host is actually a woman — 'carnal desire my ass,' sneers Jungle Lad rejecting Z-Man's advances only to be beheaded by a sword-wielding Superwoman. Following Bobby Beausoleil's arrest and revelations about his connections to the Manson Family, Kenneth Anger's *Invocation of My Demon Brother* is packaged up with *Satanis — the Devil's Mass*, a documentary about Anton LaVey, and sent out as a sexploitation double bill. In *Zabriskie Point*, the female lead looks out across Death Valley. 'OK, it's dead,' she says, 'so let's play a death game.' In *Myra Breckinridge*, film critic Rex Reed dances down the street with Raquel Welch as his transgendered alter ego.

'So I'm here for stolen dune buggies,' Manson tells *Rolling Stone* as his personal command buggy goes on display at a California car show.

Judecca to the Centre of Hell

Creatures once so beautiful...

••• ✚ •••

The elevator doors open; before entering Warhol's Factory at decade's end you find yourself confronted by bolted steel doors. A sign reads KNOCK AND ANNOUNCE YOURSELF. Shots fired — the leap from the 1960s into the future goes straight to the frozen core of hell. All climaxes are a form of perversion: an escalation of intent and permission, holding your strongest and strangest material back to keep people watching until the end, expecting the monsters to finally show themselves and perish. It is only through the line of their descent that fallen angels preserve their true beauty. Was it Andy or Charlie who said: 'No sense makes sense'? Was it Charlie or Andy who said: 'There is no why'? Try finding a thread to follow once you reach the centre. Warhol embraces the beautiful as a form of a negative space: like a projected image in the darkness of the cinema interior. It was Manson who made the first statement, Warhol the second. Welcome to a Hell without judgement — just one last frozen glance as you leave.

···✛···

Counterculture is a misnomer: defined and shaped by established power in the same way that the dominatrix is defined and shaped by the demands of her willing slave. It's the wrongness of the language — the falseness of the intention. Like a go-go dancer captured on film, the ritual is mesmerising and false — you can't look away. In *Trash*, Andy Warhol's 1970 movie release, a girl tries to persuade his newest superstar Joe Dallesandro that sex is better than drugs. 'Isn't it great when you come?' she says. 'No,' replies Dallesandro. 'It's over.' The 1930s are there again at the start of the 1970s, film culture looking back longingly at Hollywood's epigone age of boy-meets-girl: a narrative with which every movie, play, toy and machine mentioned in this book has made its own Faustian pact. Flash Gordon rides off into space one more time. Superstars and Superheroes are the first shudder of postmodernism — the *ne plus ultra* of a century mad to get ahead of itself. Leaving themselves behind, they break the rules of physics and humanity. Captain America, Iron Man, Thor and The Hulk are Pop Art takes on the Universal movie monsters of the 1930s, marking the end of the human and the start of a mythology for the next millennium. In 1971 William Burroughs, drunk on whiskey, appears as the President of the United States cynically terminating an astronaut's mission into space in a play called *Flash Gordon and the Angels*.

Faces, images, words and events from the past are pushed tightly together: crushed fragments slowly compacted into the frozen landfill of hell. For example, it turns out that Russ Meyer and Kenneth Anger have a close friend in common. Underground filmmaker and drug fiend Willard Maas was a US Signal Corps camera operator with Meyer during WWII; and Anger stayed in Maas's apartment in Brooklyn Heights while working on *Scorpio Rising*. The parody of Anger's *Inauguration of the Pleasure Dome* in Meyer's *Beyond the Valley of the Dolls* is personal on at least one level. Shots fired — Maas shares the apartment with his wife, the filmmaker Marie Menken. They throw wild parties there, attended by the likes of Frank O'Hara and the Factory crowd. Menken and Maas drink and fight with each other all weekend; their pitched arguments and crockery smashing supply the raw material for Edward Albee's *Who's Afraid of Virginia Woolf?* Menken goes on to appear in several Warhol movies, including *Chelsea Girls*. For years Warhol dreams of making a big success out of a film, play or TV series that shows people getting drunk and fighting.

15.4.07 (continued) — After the talk Ken Jacobs beckoned me over. 'That was your narrative of

what happened,' he said. 'It was very interest-
ing, but that was your view...the world is not
disappointing.' Never said it was. 'That last film,'
he continued, referring to Silent Night, Bloody
Night, *'was a piece of shit.' The Russ Meyer,*
Beyond the Valley of the Dolls, *he also said 'was*
a piece of shit', while he thought Anger's Inau-
guration of the Pleasure Dome *was great art.*
He added that I was doing very interesting work
and that I shouldn't take any of his comments
as 'meant negatively.' The trick is to write about
underground movies as though they were ex-
ploitation flicks, and exploitation flicks as though
they were underground movies.

Mary Woronov appears with Ondine, Jack Smith, Hetty
MacLise and Warhol superstars Candy Darling and
Tally Brown in *Silent Night, Bloody Night*: a low-budget
shocker first released in 1972. Woronov stars in the
main part of the movie, while the others process si-
lently through a 1930s flashback sequence near the
end. Universal horror star John Carradine also turns
in a moody non-speaking part. Two naked lovers get
chopped to pieces before they can leave their bed,
there's a plot about madness, incest and inhumanity,

XXXIV
Ninth Circle: Judecca to the Centre of Hell

and a black dog gets stabbed. In one deranged gesture, Ondine drains a glass of champagne, breaks the glass then jabs it in a sleeper's eye — the camera showing this last part from the waking victim's POV.

If a work of art betrays us, then the question of its value is without relevance. What does it matter if we consider it Trash or not? Irony mocks everything into existence. Beauty is laughed back onto the stage. Overcoming irony by ecstatically embracing irony, Trash is the affirmation of beauty to the point of its destruction. We betray beauty in order to save it.

Warhol appears as himself in a 1985 episode of *The Love Boat* alongside Milton Berle, Andy Griffith, Cloris Leachman, Tom Bosley, and Marion Ross. Raymond St. Jacques appears in drag as a member of Warhol's entourage. 'How does an artist know when a painting is really successful?' a female *Love Boat* regular asks. 'When the check clears,' St. Jacques tartly responds. While out in Hollywood to film his scenes, Warhol does a television commercial for Diet Coke and even, by his own account, 'drank it for the first time.' Andy Warhol

decides that Hollywood people are 'idiots.' 'They didn't buy art,' he is reported as saying. 'They stank.' Innocence lacks depth — or at least must appear to do so at times. In the end it becomes clear that it is not high art which has failed popular culture but popular culture which has failed high art.

18.7.13 — MS Balmoral: Innocence can be lost, never to return, but the idiot will always be with us. Foolishness can be made wise, ignorance instructed, and both can be trained. But idiocy remains exactly what it is.

'I think Trump's sort of cheap, though,' Warhol records in his diary. 'I get that feeling.' Shots fired — President Trump marks the death of irony. No sarcastic distance is too far. I remember once looking out from a train window coming into Zurich airport and seeing the words 'HELLO TRASH' painted in big black letters on the side of a high-rise apartment block. I thought of a comic-book store I saw near Ground Zero in October 2001, about a block from the Twin Towers: lonely action figures from Marvel and DC comics in bright plastic

posed helplessly in the window while the air still smelled of burning. And I thought of the attempts that Warhol made to film a 'screen test' of the elusive Marcel Duchamp, smoking and drinking and nodding silently to his guests at a New York gallery opening in 1966 — a final image warily evading the camera, fading into the darkened cosmos.

The most beautiful angel of all lives on in Milton and Blake; and Flash Gordon is just another pilgrim disappearing among the stars.